Lingerie

Lingerie

A Celebration of Silks, Satins, Laces, Linens and Other Bare Essentials

Catherine Bardey

PHOTOGRAPHS BY
ZEVA OELBAUM

BLACK DOG
& LEVENTHAL
PUBLISHERS
NEW YORK

ISBN: 1-57912-105-5

Library of Congress Cataloging-in-Publication Data

Bardey, Catherine, 1963-
Lingerie: a history and celebration of silks, satins, laces,
linens and other bare essentials / Catherine Bardey;
photographs by Zeva Oelbaum.
cm.
Includes bibliographical references.
ISBN 1-57912-105-5 (hc)

Book design: 27.12 Design Ltd.

Printed in The United Kingdom

Published by
Black Dog & Leventhal Publishers, Inc.
151 West 19th Street
New York, New York 10011

Distributed by
Workman Publishing Company
708 Broadway
New York, New York 10003

g f e d c b a

The author would like to thank Pascale
and Selima at le Corset for their generous loan of the
vintage lingerie featured throughout.

Cover
The Letter, Delphin Enjolras. France, 1857.
Courtesy of Christie's Images, New York.

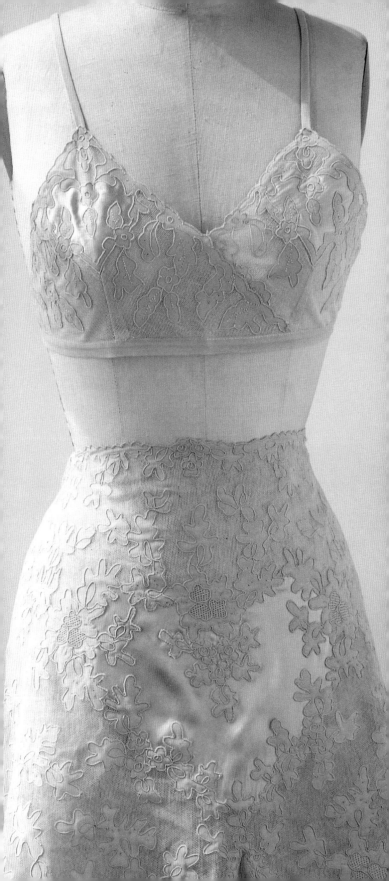

Table of Contents

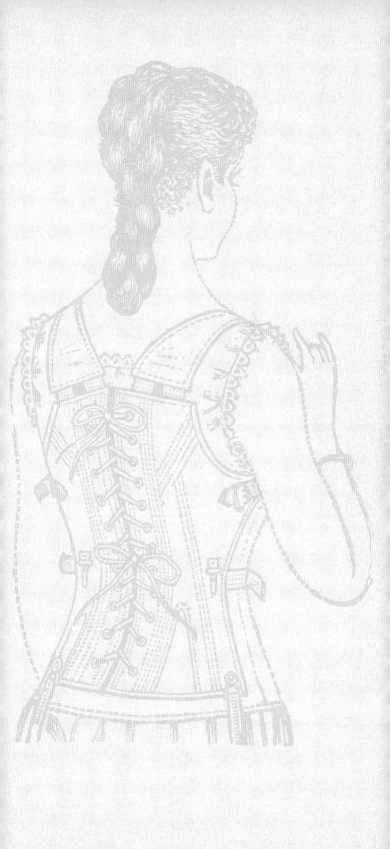

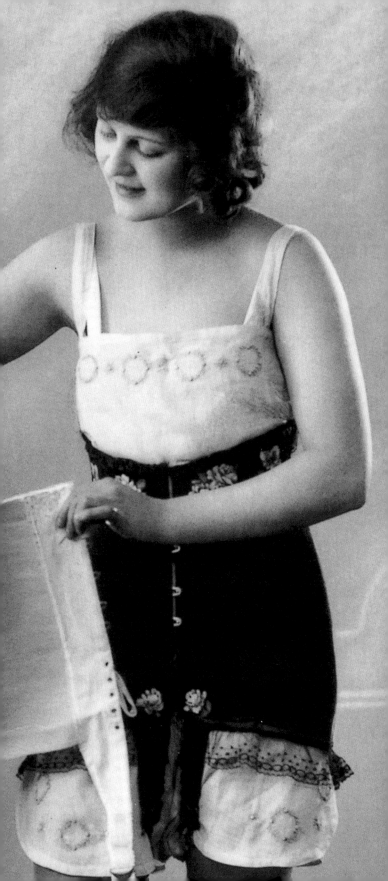

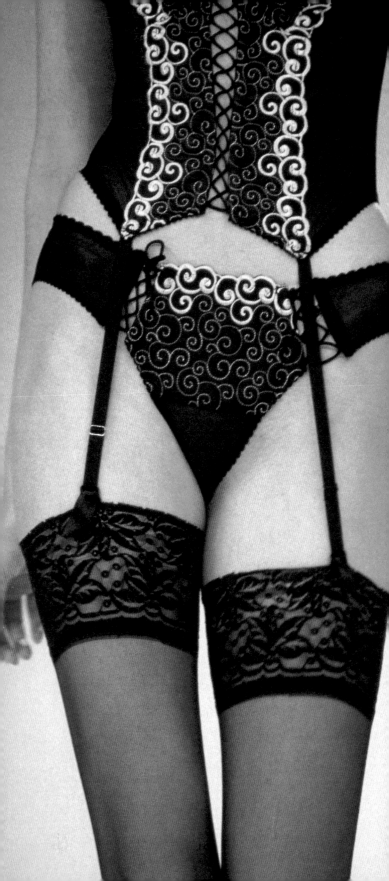

INTRODUCTION

Lingerie: Enticing, decadent, erotic, unmentionable, indecent and tabooed; mood creating, mood enhancing, sensual, uplifting, seductive, silly, frilly, fashionable, practical, comfortable and necessary.

It is hard to imagine that anything possessing such power and expression could have emerged from the loins of glue-stiffened linens, metal "cages" and suffocatingly tight laces. Or that a delicately embroidered silk G-string or a spandex sports bra was spawned from what once squeezed, cinched, bound, restrained and molded women into curiously unnatural shapes, sometimes causing permanent damage or even death.

French lingerie, 1996—too pretty to hide?

Lingerie

The history of lingerie is fascinating and perplexing, and its origins are difficult to trace. The meaning of lingerie and what falls under the lingerie umbrella has changed considerably over the years. Today's provocatively sexy and shapely "Merry Widow," a bustier-garter hybrid, can hardly be compared to the barbaric iron armor prescribed by Catherine de Médicis in the sixteenth century. Even within the same generation of women, the word "lingerie" can have multiple meanings. What might be lingerie to one woman—white cotton briefs with a crisp white T-shirt, for example—could be another's indication that all the sexy stuff is in the wash and that she's down to the bottom of the underwear drawer. Furthermore, what some might reserve for the boudoir, others use as an elegant top to a full skirt for an evening at the opera.

Lingerie has served as an effective barometer of female identity and is emblematic of the hoops through which women have jumped to attain independence and self-fulfillment. Weaving in and out of trends—with waists, hips and breasts constantly made to expand and contract like rubber bands—lingerie has traveled through the lives of ancient athletic Cretans, the restraint and self-discipline of the Elizabethans, the "forbidden sexuality" of the Victorians, the sex symbolism à la Jane Russell, and through the bra-burning emancipation of the 1960s. It has provided fascinating insight on the effect various social, political and economic climates can have on women's undergarments. And, of course, it has fallen prey to the forces of human vanity and succumbed to the whims of fashion.

From its multiple purposes and functions throughout history, and the delicious words used to describe it, lingerie has emerged titillating and triumphant: from fodder for a scintillating conversation to unquestionably erotic attention-grabber. ("Wait 'till Stephen sees me in this little num-

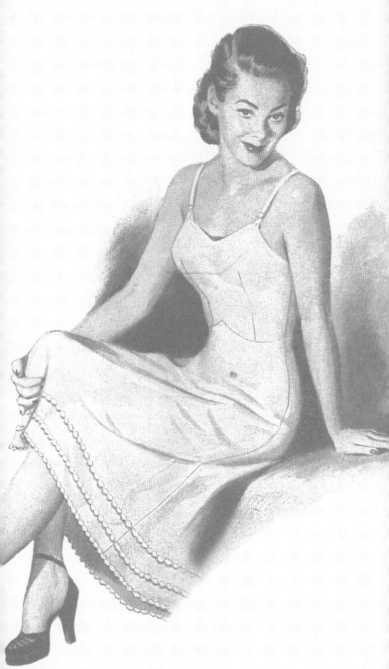

"Your length with a snip," promises this 1948 ad
for an adjustable slip, from **Vogue.**

The world's first 24-carat gold bra.

ber!") In certain cases, the garment itself plays an essential part in what triggers the desire to entice and to seduce. There is no doubt that a contemporary black leather corset with garters or an embroidered-lace bra with a low décolleté is seductive, or enticing at the very least. In others, as in the nineteenth-century bustle—an awkward pillow-like piece attached to the waist to give the illusion of a protruding posterior—the garment constructs a shape, and the shape itself, not the undergarment, is the seductive element. The shape seduces because it invites speculation and adds mystery as to what might lie underneath. Whatever the reason, one cannot help but associate undergarments or lingerie with the world of erotica.

Lingerie also remains an effective means of self-expression and sexual appeal. It continues to pique the interests of *haute couture* designers, and to seduce the viewer. Every season a different novelty item, such as

an angora bustier or a $10,000,000 bra encrusted with diamonds and sapphires, makes its début on the front page of fashion catalogs. And just when the world of lingerie has surpassed its own limits and transcended the extreme, strawberry-flavored edible panties, aloe-filled bras or mood-reading underwear find their way into stores and onto the pages of magazines.

Amidst push-ups, cross-backs, cleavage-enhancers, high briefs, low riders, boy's cuts, though, another trend appears to be inching its way

By giving up steel-boned corsets, women helped save 28,000 tons of metal, enough to build two battleships.

Lingerie

In the mid-eighties the "tan-through" bathing suit was introduced, promising to eradicate unsightly tan lines with its miraculous tan-permeable fabric.

forward—minimalism (as in "less is more"), especially in the underwear department. As G-strings and thongs are becoming *de rigueur*, so too is the notion of going sans underwear, a concept familiar to the twelfth-century woman who had not yet experienced the sensation of a garment that is "drawn over the legs and begins as a tight-fitting form of hosiery."[1] Conversely, as undies get skimpier and almost disappear, visible bra straps under sundresses or tank tops have emerged from slumber and have embraced an almost accessory-like quality, the latest made out of sheer material or clear plastic so as to virtually blend into the skin. So then, could it be that "lingerie" as a concept is coming full circle, in that, like our ancestors, we will live naked underneath our clothing? Is *not* wearing underwear the ultimate expression of emancipation, or is it just more comfortable? Could technology become so sophisticated that fabrics emulating human skin, imperceptible to the touch and almost invisible to the eye, could be used to make underwear that feels like nothing at all? Or is the trend toward minimalism some covert ploy to create more room in the underwear drawer for socks? Regardless of the reason, lingerie—even if invisibility or quasi-absence is what eventually defines it—continues to stir up the imagination of fashion designers, wearers and viewers.

And one thing remains certain—there's no such thing as too much of a good thing. A red silk bra with matching panties, a midnight blue, hand-embroidered satin bustier or a black sateen and velvet "Merry Widow" with matching garters is always a very, very good thing...Just ask Stephen.

In 1999, Brandi Chastain of the U.S. Women's Soccer team kicked an awe-inspiring, game-winning overtime penalty shot against China in the World Cup Final. She celebrated by whipping off her jersey to reveal the no-nonsense sports bra beneath.

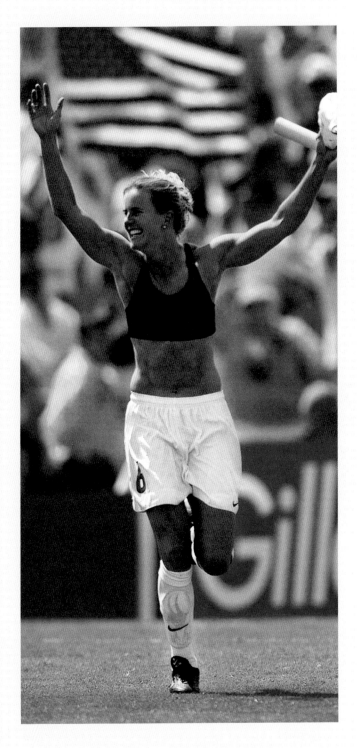

LINGERIE MUST HAVE
NO. 1

❧

*The sexy bra with
matching panties.*

❧

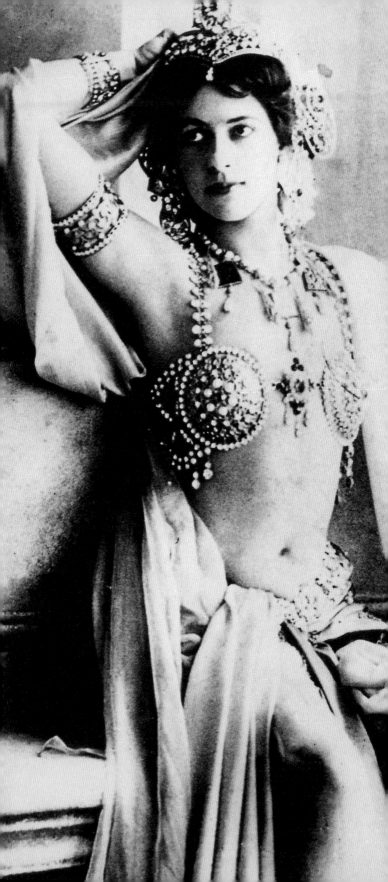

IN THE BEGINNING

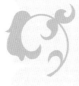

Before the mid-nineteenth century, women's under-linen and underwear were called "underclothes" or "undergarments." Afterwards, these garments became known as "lingerie," a word derived from *lin*, the French word for linen, linen draper, or "loosely hanging clothes." In the 1850s *Godey's Lady's Book*, a publication replete with fashion, dress instructions and "elegant literature" that was managed by "one who knew the want of the time, and had the tact and taste required for its supply," made the name "lingerie" official.[2]

Dutch dancer and spy Mata Hari, wearing a jeweled dancing costume with a brassiere top, c. 1900.

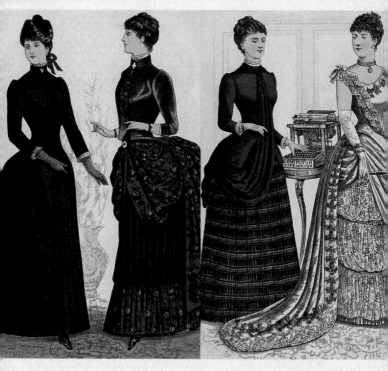

*Fashions from the 1850s, as portrayed in **Godey's Lady's Book**.*

Incidentally, the very proper and popular magazine, which contained headings such as "Points of Etiquette" and editorials entitled "Heart Service in the Cause of Humanity Belongs Naturally to Women" and "Genius Has No Sex," was created, published and edited by a man: Louis A. Godey.

About forty years later, in the 1890s, lingerie took on the characteristic of "fine luxury underwear in silk, satin, and lace." Since then, the meaning of lingerie has continued to expand to such a degree that defining it has become increasingly difficult. Defering to the "you'll know it when you see it" approach is likely to be the safest litmus. Today, the spectrum of lingerie covers everything from frilly, hand-embroidered lace camisoles to sports bras or ski underwear and underwear worn as outerwear, a trend which Madonna, the famous pop artist, is almost exclusively responsible for setting.

To fully appreciate twenty-first-century lingerie and to

understand its evolution—from its most archaic form (loincloths or animal skins) to sophisticated designer pieces—one must peek up the petticoats of time and explore its "whens, wheres and whys," in relation to the world of fashion. One thing is certain: G-strings, thongs, string bikinis, corsets, bodices, bustiers, Merry Widows, camisoles, demi bras, full-coverage bras, seamless bras, sports bras, strapless bras, bralettes, bandeaus, cleavage enhancers, steel corsets and Spanish farthingales share a common ancestor that replaced nudity with a garment that distinguished itself from other clothing as an "undergarment." The exact genesis of the undergarment is difficult to pin down. First of all, there is the scarcity of physical evidence; second, there is the disparity between

In 1991, mountaineers in the Tyrolean Alps came upon the frozen body of a 5300-year-old man. His clothing included animal-skin leggings and a leather loincloth.

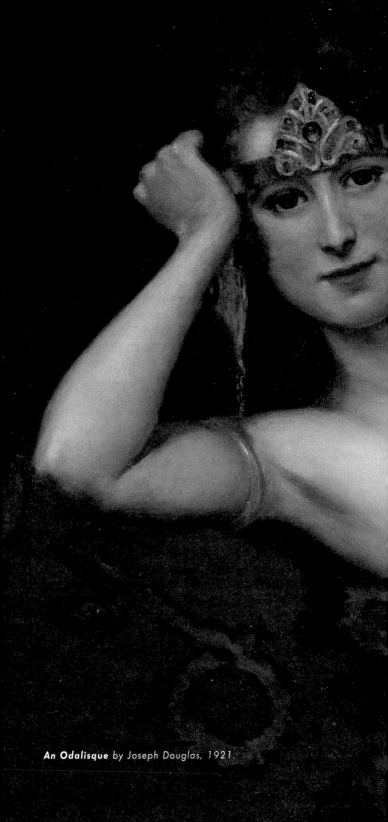

*An **Odalisque*** by Joseph Douglas, 1921.

the evolution of clothing and that of underclothing (just because our ancestors started to wear clothes doesn't mean that they were wearing garments underneath them); and finally, there is the fact that one civilization's undergarment might be another's clothing. In light of these difficulties, some historians have turned to "close-fitting garments"—clothes that are in direct contact with the skin, as a place to start. Others have suggested that Genesis 3:7 alludes to Adam and Eve's strategically placed fig leaves as the very first caches-sexe, or cover-ups, born of modesty.

> *And the eyes of them both were opened,*
> *And they knew that they were naked:*
> *And they sewed fig leaves together,*
> *And made themselves aprons.*[3]

And some underwear afficionados have proposed that the fig leaves were held in place by long stems of grass picked from the Garden of Eden and woven into the leaves, making the G-string the great-great-great-grandmother of all underwear.

Whatever its origins, however, lingerie today is a complex merging of three different types of undergarments, of three separate entities: corsets, crinolines, and a third, much less-defined category that incorporates pantaloons, chemises, and under-drawers. Each with its own style, personality, purpose and function, and with a shared genealogy that possibly stems from a fig leaf, the speculation as to "what lies underneath" is indeed mysterious.

Eve wearing her biblical undergarment,
the fig leaf, as painted by Albrecht Durer in 1507.

LINGERIE MUST HAVE

NO. 2

❧

The Camisole Set

❧

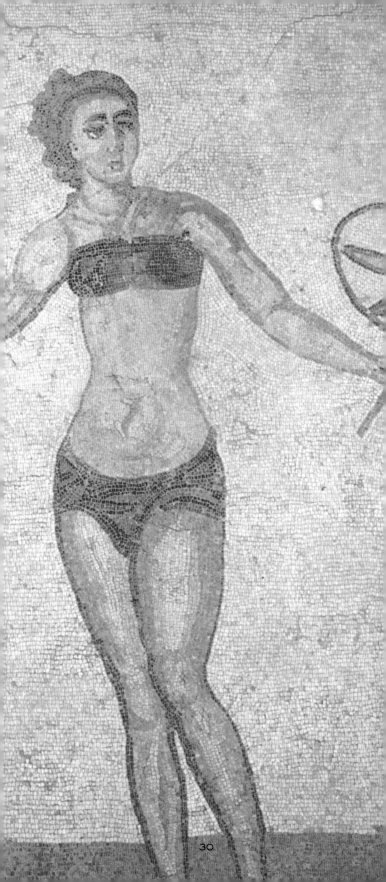

THE VERY
EARLY YEARS

A
BRIEF RUN-THROUGH

The first example of a close-fitting garment is found on a small Greek sculpture dating from 3000 B.C. The figurine is that of a female athlete, or perhaps a slave, wearing what looks like a pair of briefs and a necklace. Experts speculate that these briefs were worn to minimize chafing caused by the usual loincloth slung between the legs.

In 1352 BC, Egyptian King Pharaoh Tutankhamen was buried with 145 loin cloths.

Women athletes, dressed for sport, can be found in the 2nd-4th-century mosaics at Piazza Armerina in Sicily.

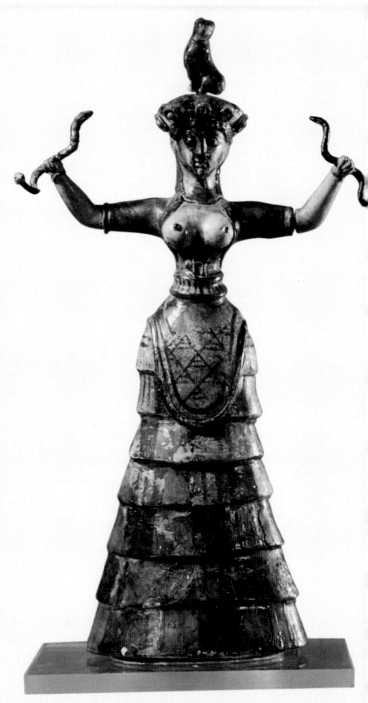

This powerful Cretan Snake Goddess, wearing a garment that cinches her waist and bares her breasts, dates from 2000 B.C.

The next example, dating from around 2000 B.C., adorns a Cretan statuette of the Snake Goddess from the Palace of Knossos. The statuette is wearing a tight-fitting garment that resembles a bolero jacket, which hangs from the shoulders and upper torso down to the waist. The garment is laced up to the area just below the statuette's breasts and is bare in front, revealing her breasts. Considered a predecessor to the corset, the garment effectively cinches her waist and pushes her breasts together so that they are protruding and remain erect. The Goddess is also wearing a flouncing skirt to further enhance her small waist, producing an effect similar to the exaggerated width of crinolines and petticoats of the Victorian era. In essence, the large circumference enveloping the lower body gives the appearance of an even smaller waist.

After the Snake Goddess, concrete examples of undergarments are few and far between until we get to ancient Greek and Roman times. Grecian women in particular lived athletic lives. They set a high value on physical perfection of the body as is evidenced by illustrations found on ceramics and various artifacts. Although banned from partaking in the Olympic Games, women of ancient Greece had an athletic competition of their own, a 500-foot race called the Heraea, in honor of the goddess Hera. Dancing, too, was a popular fitness activity, intricately woven into social and religious functions. Body movements made breast- and waist-support a necessity. Written records from 450 B.C. indicate the existence of a type of girdle that was made out of wool and worn around the waist and hips, and the first bra prototype that consisted of bands of woolen cloth with which to bind their breasts. The purpose of these woolen garments was threefold: to keep the body in place, to minimize the size of the bosom, and to reduce its bouncing. Wool was chosen to protect the body from changes in temperature.

From the bra prototype up until the late thirteenth and early fourteenth centuries, evidence of undergarments was relatively scarce, with the exception of a trouser-like garment that was introduced by the Romans. In the 4th century A.D., the seat of the Roman Empire moved to Constantinople, which meant adapting to a different climate. To protect themselves from the cold, Roman soldiers started wearing trouser-like bottoms and loose-fitting tunics, which are believed to be ancestors to men's underpants, women's knickers and chemises. In addition to this

> *Arab women tend to be covered from head to toe, but are unlikely to be wearing underclothing even today.*

new look that they brought home, the Romans also came back with the riding of animals as a means of transportation. In order to meet the needs and challenges of an equestrian society, clothes were pulled closer to the body to minimize contact with the animal's legs. This fashion, borne from practicality and necessity, was soon reflected in the everyday wear: loose tunics were drawn tightly to the body, shaping it with ornamental girdles and decorative ropes.

Leon Bakst portrays Salome in
***Dance of the Seven Veils**, 1908.*

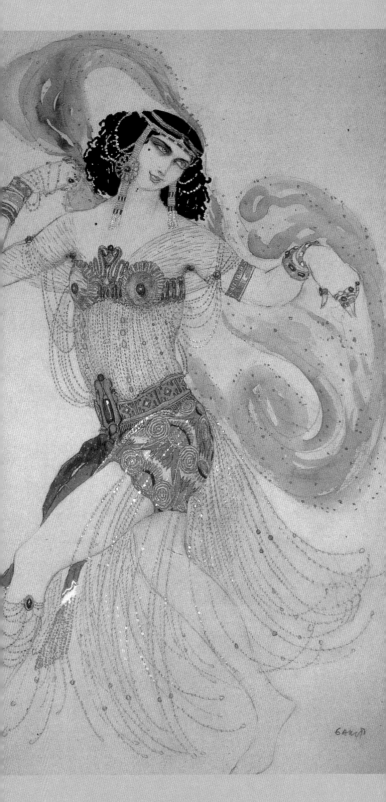

ONE
STEP FURTHER

In the late thirteenth century, the Crusaders returned to Europe after their two-century-long quest to recover the Holy Land from the Moslems. They brought back many riches: costumes, foods, textiles, dyes and colors, fashions and the glass mirror—the perfect fashion accessory. They also returned with the Eastern concept of femininity, manifested by clothing that outlined the shape of the female body and acknowledged its curves.

European women were quick to embrace the clothing style of their Eastern counterparts. To enhance their natural curves, European women cast aside their loose-fitting robes and replaced them with close-fitting garments that had laces incorporated into them. The laces were wrapped externally around the waist, hips or under the bosom to contour the lines of the body and show off the figure. Lacing was such a prominent feature in the fashion of the time that it made its way into men's fashion as well. Gradually the laces became tighter and more gathered, eventually becoming a separate garment altogether and worn over the smock or chemise. This garment would later be known in the sixteenth century as "a pair of bodies," a rigid covering for the upper body made of two halves laced together; in the seventeenth century as a bodice; and in the eighteenth century as "a pair of stays." An obsession with a narrow waist had begun to take hold.

Around the beginning of the fourteenth century, with the Renaissance as the perfect backdrop, the concept of fashion was quickly emerging. Colorful fabrics and a variety of textures inspired the desire to create elaborate and decorative clothing with new silhouettes. For the first time, the concept of clothing as fashion became distinct from clothing as a mere practicality. To enable and facilitate the creation of these fashionable clothes, undergarments began to take on a new role. Instead of

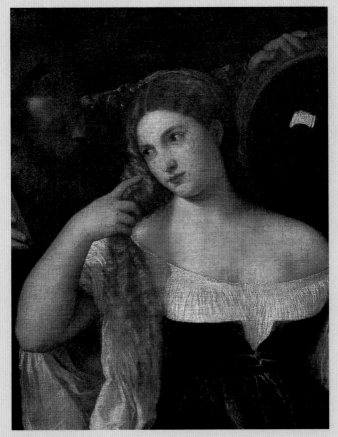

Titian's **Portrait of a Woman at Her Toilette**, 1570.

being mere undergarments, they became a foundation on which to build an external silhouette. Certain pieces, later known as corsets, reduced and molded certain parts of the body. Others, like the crinoline, expanded or exaggerated bodily contours. And finally, another set of undergarments altogether, perhaps more fluid and a bit more discreet in their form and function, emerged to bridge the gap between the structured corsets and rigid crinolines: the chemises, pantaloons, and under-drawers.

Eastern European women are twice as likely to wear a bra as their Western counterparts.

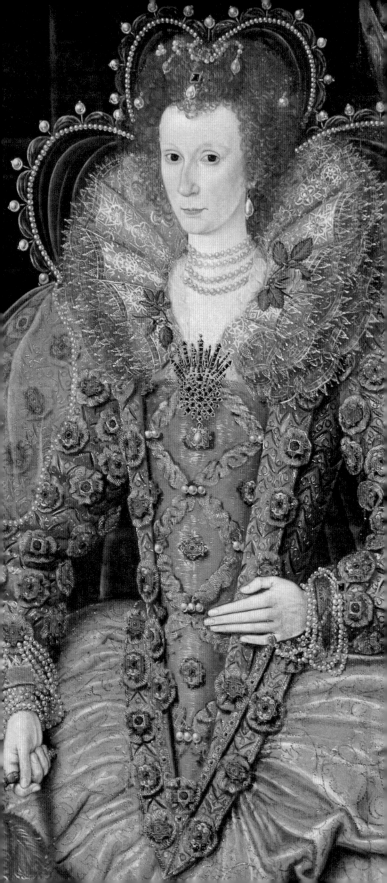

CORSETED
&
CAGED

By the fourteenth and fifteenth centuries, the obsession with fashion, predominantly defined by the size of a woman's cinched waist and the circumference of her hoop skirt, was in full bloom. A woman's sense of self, her wealth and social status (usually defined by her husband's) was reflected in her measurements, with the width of the crinoline and narrowness of the lower torso serving as accurate barometers for determining class. Indeed, an impossibly large hemline and constricted ribs with a tiny waist were veritable signs of fifteenth-century *bourgeoisie*.

As early as the 16th century, women wore scented pomander between their breasts (a reminder of which can be found today in an embroidered rosette at the center of some bras) to repel body odor.

Queen Elizabeth of England, 16th century.

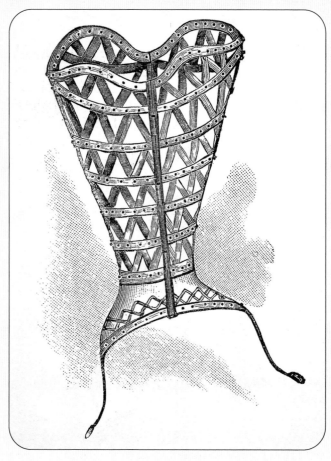

A steel corset cover that Catherine de Medicis might have worn in the 16th century.

With tighter corsets, expanding crinolines, and an exponentially increasing number of petticoats, physical activity became a challenging endeavor and was kept to a minimum. Even the most basic of functions—bending down or standing up—were impractical and awkward, encumbered by excess weight and unnatural dimensions. Imagine having to sit down at a dinner party while negotiating the rigid sides of a ridiculously large skirt expanding three feet in all directions, or surrendering to a corset cinched so tight that even coughing becomes hazardous to your health. Now imagine doing this while trying to be graceful. As a result of these self-imposed physical restraints, women were essentially subdued into levels of complete inactivity, leaving stretching and bending—

and most everything else—to the hired help. Without the aid of cooks, maids, *femmes de chambre*, wet nurses and nannies to serve as the arms, legs and body of their mistresses, life would have been impossible. In fact, the more inactive the lady of the house, the larger the staff—and a large staff was always clear reflection of the wealth of the household.

The concept of restraining and constricting a woman and of distorting her physique to indicate beauty, social status, marital status, or to serve as an imprint or brand (in the sense of an identifying mark to show ownership, quality or stigma) is certainly not new. It is a timeless and cross-cultural practice. From the Roman chastity belt and the Athenean "zona" (a cloth or leather girdle-like garment worn to accentuate the figure and emphasize femininity) to the light-laced wasp-waist corset of the 1800s, the female body was restricted in one fashion or another throughout the centuries. Edwardian women encased themselves in various contraptions to achieve the S-shaped silhouette, a bosom-heavy, tiny-waisted, posterior-protruding figure popular at the time. While American women of the late 1910s were brandishing their corsets and struggling for the right to vote (ultimately granted in 1920), Chinese foot-binding, a painful, crippling process meant to make women more sexually exciting, dependent and less likely to stray, had just been outlawed. Today, the Padaung women of Myanmar continue to wear brass coils around their necks. These coils can weigh as much as eleven pounds, elongating the neck by pressing on the collarbone. Should a woman decide to leave the tribe or act in such a manner considered contrary to the tribe's traditions, her coils are removed, causing asphyxiation because her neck muscles are too weak to support her head.

Certain tribes in northern Kenya continue to scar their faces and bodies as a way to beautify, to distinguish themselves from other tribes and to indicate their social status. In other parts of the world, plastic surgery, laser hair-removal and tattooing remain the beautifying

In 1873, 7 to 10 pounds of underwear was considered a normal complement.

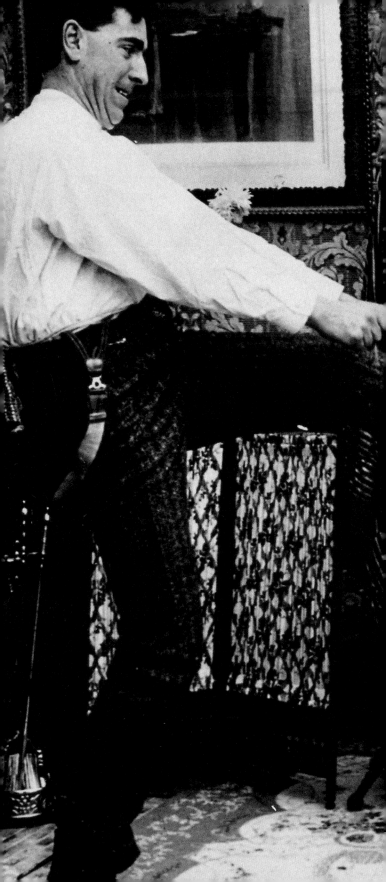

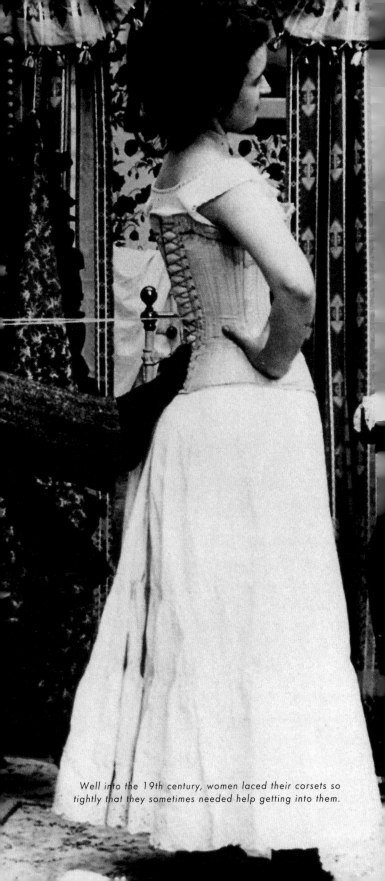

Well into the 19th century, women laced their corsets so tightly that they sometimes needed help getting into them.

methods of choice.

Depending on the culture, a woman's body markings (whether through self-inflicted scars or tattoos), exaggerated curves and contours appeal to a man's paternal, nurturing and sensual needs. Certain historians have argued that the focus on, and quasi-obsession with, appearance was predominantly initiated by men who felt that it was best to keep a woman's mind preoccupied with fashion and out of political, economic and social affairs. The same historians have also argued that men, especially during the Victorian era, were torn between their attraction to women and their desire to keep women under wraps. Similarly, women were caught between the desire to be alluring at almost any physical cost and their burgeoning drive for emancipation. How women perceived themselves and how they thought others perceived them had a direct impact on what they wore next to their skin.

In mid-fourteenth-century Europe, signs of waist restraint in the form of belts and sashes wrapped around the midsection made their debut. They remained relatively innocuous compared to the cinching that was yet to come. Most likely, the first to engage in such practices were older women who had lost their figures and were tightening up their bodices to get some curves back, or women who never had any figure in the first place. In the early fifteenth century, as fashion was calling for a smaller waist, an undergarment known as the *cotte* was introduced. The *cotte*, whose name is derived from an old French word for "close-fitting garment" and "rib" (*côte*), was constructed of two layers of linen often stiffened with paste and wrapped around the waist to make it smaller. It was worn under the outer layer of dress but over an under-bodice or chemise, the garment closest to the skin. The *cotte* was relatively harmless, for its purpose was to hold in the flesh and not actually distort it.

By the end of the fifteenth century, however, the development of the silk industry and the latest wave of fashions emerging from Italy and Spain fueled the obsession with waist size. In order to sustain the weight

Puritans called "farthingales" the work of the devil and accused women of hiding men under their skirts.

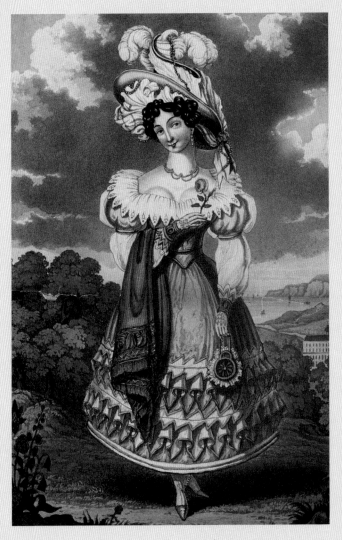

In the 14th century, belts and sashes served as waist restraints, pre-figuring the more severe cinching that would follow.

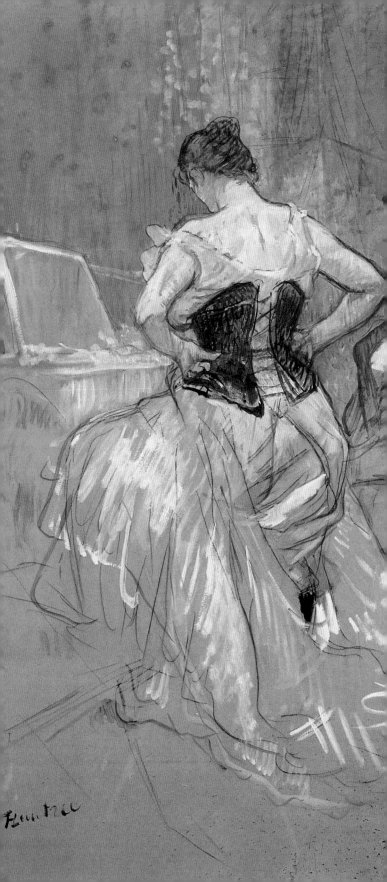

A woman dons her corset in Henri de Toulouse-Lautrec's
The Conquest of Passing, 1895.

of the newest textiles—rich brocades, velvets, damasks and silks—the torso needed extra support. Layers of fabric that bulked at the waist required severe cinching and actual shrinking of the stomach, waist and hips to meet desired proportions. And in addition to physically altering the dimensions of the waist, the illusion of a smaller one could be achieved by wearing a cone-shaped structure that sloped downward and outward from the waist down to the ground.

For these reasons, the busk, a very early form of the corset, and the farthingale, the great-grandmother of the crinoline, were introduced. The busk—inserted into a tight-fitting bodice—was worn over an undergarment like a chemise or an under-bodice and under the outer dress. The farthingale—an encasing hoop made from whalebone, steel, ivory or wood—was the first aid or support to the frame, providing the necessary scaffolding to produce an artificial silhouette.

Over the centuries, the busk evolved considerably. With each evolution, it took on a different name and its design changed accordingly, imposing varying degrees of physical restraint. But the basic concept—from the "pair of bodys" [sic], the "pair of stays" to the corset—stayed the same: these body-cinchers squeezed, distorted, shaped and molded the waist to unnatural proportions.

Similarly, the farthingale evolved, changing its name and slightly altering its design and construction. From the whaleboned petticoat to the hoop petticoat, the panier and the crinoline to substitutes like the bustle or the bum roll, all were created to exaggerate the smallness of the waist and to provide an interior framework for an artificial silhouette. They were restricting, constraining and awkward, and like the cinchers, all came and went, only to resurface and retreat again a few years or centuries later, depending on socioeconomic and political penchants and women's identity at the time.

LINGERIE MUST HAVE

NO. 3

❧

The Corset

❧

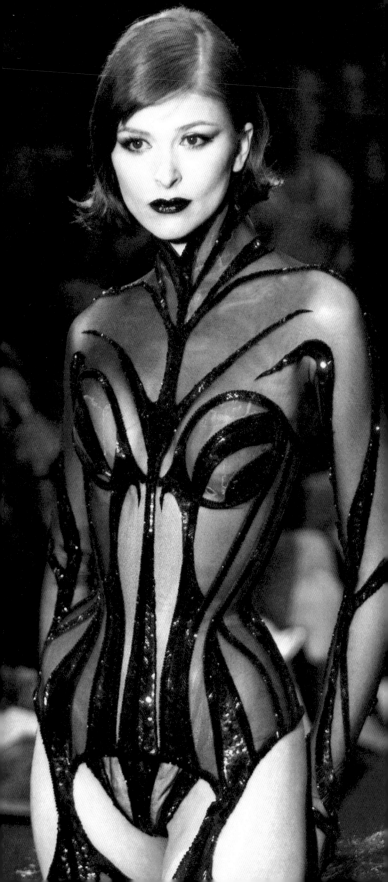

THE ULTIMATE CINCHER

Considered by many to be the pinnacle of the suggestive and of the unmentionable, today's corset stretches the perimeter of temptation and flexes the muscles of sexual fantasy. It is seduction at its best. The contemporary version of the corset and some of its cousins—the *guêpière*, the waspie and the corselette—are considered pillars of erotica. One of the most provocative items of lingerie, the corset, elicits eyebrow-raising responses from both sexes. Its silhouette on the silver screen inspires countless designers from Vivienne Westwood to Thierry Mugler to Jean-Paul Gaultier, and intrigues new generations of fashion aficionados who yearn for its comeback.

Thierry Mugler's racy reinterpretation of the corset was a highlight of his 1999 collection.

The corset conjures up as many images as it has styles. With silk trim and rich brocades, it is the icon of the boudoir, evoking swelling bosoms in a moment of passion. It enters the worlds of fetish, fantasy and eroticism with its leather laces, straps and metal rivets. With cone-shaped cups and a fashion designer's flair, it becomes a rock star's signature apparel; coupled with a long, lace-edged half-slip, it adorns the pages of *Vogue* magazine and is described as elegant outerwear, one of evening's must-haves.[4]

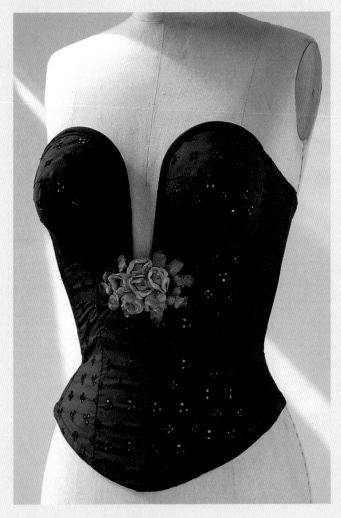

Christian Dior's classic black bustier is too elegant to keep under wraps.

Lingerie experts argue that the corset's comeback indicates a return to femininity that goes hand in hand with exaggerated high heels, breast implants, padded and push-up bras, and cleavage-enhancers. Experts also argue that it reflects a relaxation in our moral standards by allowing what used to be closet fetishwear into the mainstream. Others insist that there are women who continue to embrace corsetry as a way to manipulate their bodies and to actually reduce their waist size by three or five inches. Or that perhaps wearing a corset is an atavistic throwback, like living a moment from another time, or that certain women enjoy the feeling of being slightly constricted. Regardless, most agree that today's corset gives women a feeling of power and makes them irresistible, and leaves most viewers speechless.

While studying the evolution of lingerie, and corsets in particular, one cannot ignore their harsher and more prurient beginnings. The corset has not always been the favored child of the lingerie world. It has been compared to an updated version of the chastity belt of the Middle Ages, vehemently rejected by the medical community for causing discomfort, fainting, nausea, rib-piercing, and sometimes death. It has been labeled as man's last-ditch effort to keep women subdued and dependent, and also described as lunatic in its extremes. Some have also described it as the original contraceptive because by the time the woman managed to remove it, the man had lost interest.

From an aesthetic perspective, the corset suggests the tension between femininity and eroticism, imposed oppression and self-imposed restraint. Antique corsets are delicate, beautiful and well-crafted garments. Hand-stitched in rich sateens, silks or silk brochés, embroidered with tiny ruffles and lace, and sometimes reinforced with intricately carved whalebone busks or stays, their workmanship is spectacular. But no matter how luxurious, the antique corset's purpose was very specific: it was meant to constrain and distort the shape of a woman to fulfill the concept of the ideal feminine physique. It was not until the late nine-

In the 1900s, lace-edged pantaloons peeked out from under skirts and incited men to such a degree that the garments were eventually prohibited.

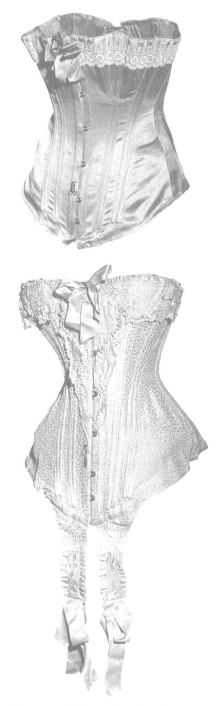

The evolution of the corset, 1850 (top) and 1900.

teenth century, when elastic inserts started replacing rigid stays, that some of the pain resulting from wearing tightly laced corsets was reduced. And, gradually, with the relaxation of social and sexual morés and socio-economic factors that made it altogether impractical, the corset literally lost its hold and finally met its demise in the early twentieth century.

The corset has undergone many transformations in design and craftsmanship since the appearance of its earliest form, which is most likely the *cotte*. It has fluctuated from constriction and self-restraint to slight relaxation and occasional ease, then back again to constriction, depending on the overall climate of a particular era. It has aesthetically and, to a certain degree, intellectually defined and redefined the ideal woman by its presence and by its absence. The antique corset has inevitably been adulterated, like so many other trends, by the whims of fashion, the desire to seduce, the need for self-expression and, of course, the power of vanity. The corset's primary purpose always remained constant, while physical injury as a result of its extreme measures remained secondary.

An ad from the 1880s.

As mentioned earlier, the *cotte*, consisting of two layers of linen stiffened with glue, was one of the earliest undergarments whose purpose was to make the waist smaller by holding in the flesh. But with the introduction of more elaborate fashions and heavier fabrics, the *cotte* was no longer sufficient. A more draconian device was necessary to meet the demands of fashion, which called for an ever-increasing number of petticoats under a skirt. After all, the more voluminous the skirt, the higher the social standing of the wearer.

The busk (or busc or basque), in combination with an outer garment called the bodice, was specifically introduced with the heavier fabrics and additional petticoats. The busk-bodice combination is considered by many lingerie specialists to be the first artificial support to the body.

No. 2.—Gray's Shoulder Brace; can be highly recommended for all persons with weak backs or stooping shoulders.

Advertisements from Strawbridge & Clothiers Quarterly, 1800s.

The busk—a form of which would come back as outerwear on the fashion catwalks of the 1990s—was a removable strip of horn, metal, wood or whalebone that was oblong, pear- or spoon-shaped. Ornately carved, the busk was inserted in between the layers of the bodice to make it straighter, tighter and more resilient to fabric weight. It was held in place with the busk-lace, which a woman often used for flirting. To let

The Double Ve Waist

STYLE

NO. 52

FOR

LADIES

AND

MISSES.

No. 8.—The Double Ve Waist; for ladies and misses; one thickness; price, $1.00.

a man know that she favored him, she would remove it from the bodice and tie it around his wrist, arm or hat. The bodice consisted of two pieces of linen stitched together and fitted at the waist. Sometimes it was stiffened with glue and molded to the desired waist size before it hardened, a process that was also used in corset manufacturing during the late nineteenth century. The bodice evolved into a pair of bodies and

was stiffened further by adding whalebone and lacing to its sides, front and back. When it became fashionable to wear gowns that were open in the front, the stomacher, a piece to hide the front lacing, was added.

In the sixteenth century, upper-body restraint and waist sculpting were at their peak. The spirit of nationalism that prevailed in Europe at the time manifested itself by finding its identity in the royal courts. Every aspect of life—whether political, social or economic—revolved around the court and what the court dictated. A complex structure based on status and wealth determined who filled what position under which circumstances and in what particular circle. The tight structure of the court and the precision of its regulations were reflected in all forms of etiquette and social functions, from the rigidity of the attire to the shape of the body.

For example, Catherine de Médicis, often considered to be on the cutting edge of fashion, actually dictated a rigid construction of the female shape with an ideal waist measurement of thirteen inches! To achieve this particular look, also copied by Queen Elizabeth I and other crowned heads of Europe, women wore a tightly laced undergarment under an armor-like frame of intricately and precisely placed metal plates. In other words, they jammed their upper bodies and waists into iron corsets to mold them into completely unnatural shapes. These iron armors, or iron maidens, restrained a woman's level of activity in many ways. Social dances were more like pageantry because women could not move with ease. It was difficult to sit, bend or move naturally. More important, iron maidens caused serious medical problems such as diminished appetite, fainting, loss of color, abdominal pain, rib cracking, and liver piercing, some of which even resulted in death. The irony is that these iron corsets were imposed by matriarchs, which offers a different perspective to the theory that corsets were imposed by men as a way to keep women idle and dependent. Since Catherine de Médicis, the doyenne of fashion, wore one herself, one could speculate that this

The average waist size during the Flapper Years was 74 inches, as opposed to 56 in 1889.

trend was inspired primarily by fashion and van-
ity. On the other hand, some doctors of the time
proffered that iron maidens were worn for health
reasons—perhaps Queen Elizabeth I really did suf-
fer from a bad back.

The rigid constriction of the female body contin-
ued through the beginning of the seventeenth cen-
tury under the Puritan regime in England. Although the Puritans con-
demned some of the frivolous ways under the reign of Charles I, they
favored iron corsetry, but not in the way that Catherine de Médicis and
her female counterparts did. Instead, they saw it as a way to further
enhance the prevailing notion of self-discipline, rigidity and conformity.
When the Puritan regime ended, however, and Charles II took the
throne, the pomp and formality of the court gradually relaxed. Women
no longer relied on iron corsets to achieve the desired silhouette. They
returned to bodice lacing and the busk, which in some form or another
would continue to be used until the early nineteenth century as a support
to the upper body.

In late-seventeenth and early-eighteenth century France, the bodice
became known as the *corps baleine*, baleine being the French word for
whale. Whalebone, which was more flexible and easier to work with,
had replaced steel or wood supports in the bodice. Incidentally, the
excessive use of whalebone helped develop one of the biggest indus-
tries in New England and built many of its oldest fortunes. Nantucket
and Boston were put on the map as their ships would head off to the
coast of Australia in the South Sea Islands, a prominent center for whal-
ing. Since Europe had no other sources for whalebone, New England
had cornered the market in the whalebone trade. The amount of whale-
bone used was so excessive that the stiffening alone weighed up to two
pounds. The weight of the bodice and its extreme compression of the
waist caught the attention of doctors for the first time, initiating protests
that unfortunately were quickly quelled by the demands of fashion.

After the French Revolution in 1789 and during the period of the
Directoire that shortly followed, the social order had been completely
overturned, and the sense of relief and decadence that followed was
reflected in the fashion of the time. Members of the *Directoire* used the
political and social structure of the first republic of ancient Greece as a

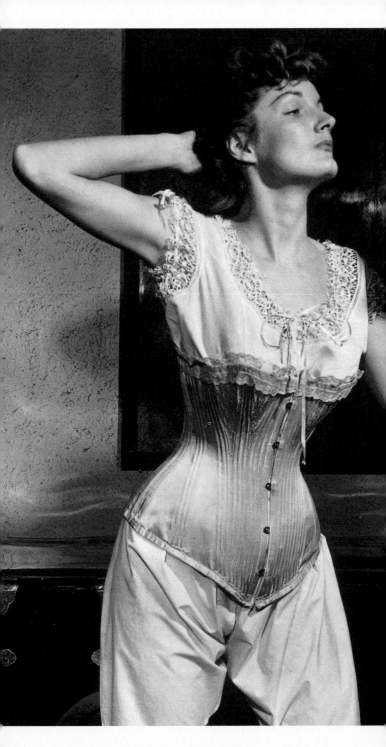

Whalebone corsets lost favor during some periods, but have always come back as part of the endless pursuit of the hourglass figure.

model for their democratic reform. Greek styles and costumes were brought back in style. Rounded breast and well-rounded figures were considered the ideal female physique of the time and were compared with the classical silhouette of the Venus de Milo. Tight, constricting garments were replaced by light, one-piece muslin dresses worn over flesh-colored tights. These dresses clung to the body and showed off its curves. All excess material and stays were discarded. The Empire Line, also called *vêtue à la sauvage* (loosely translated "the wild style"), soon spread to England when the famous French dressmaker Rose Berlin packed her bags and moved across the Channel to England. It was during this period that women would experience an ease and comfort they hadn't felt in years. The

By 1830, the waist had become so small that the most envied one could be measured with two hands.

whaleboned body, or stay, became temporarily obsolete.

The Empire line had a short life. Women with fuller figures did not like having their contours exposed and they felt naked. Light, flowing dresses appropriate for Grecian weather and lifestyle did not work as well in the cold and damp climates of Paris and London. By 1810, a light whaleboned waist corset emerged, and by the 1820s, a constricting version of this same corset became fashionable. It was one of the first corsets that separated the bust, which until then was a monobosom, by providing cup sections to replace the busk, along with a triangular piece

The Empress Josephine, garbed in the Empire style, painted by Francois Pascal Gerard, c. 1830.

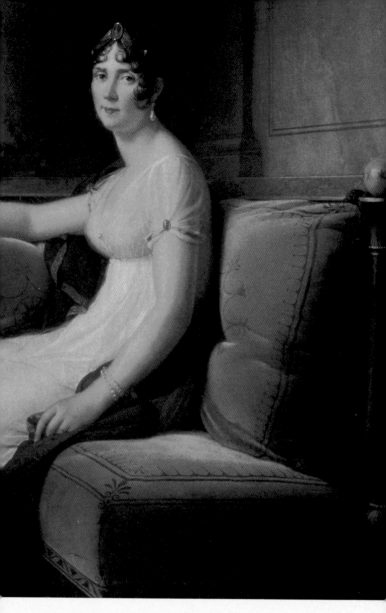

of metal in between the cups to define the separation of the breasts. This corset was called the divorce corset. The mechanical corset, with pulleys to lace and unlace it unassisted, made its first appearance at the Exposition Universelle in 1823. A few years later, the rigid court formality that had been abolished during the French Revolution returned. The silhouette of the ideal woman was the hourglass figure. Waist size was so small that the perfect waist could be measured with two hands. By the 1840s, corsets had become complicated steel and leather-encased contraptions that were practically impossible to take off and put on again. Women kept them on for days and used back scratchers to get at those hard-to-reach spots. Sanitary conditions were at an all-time low.

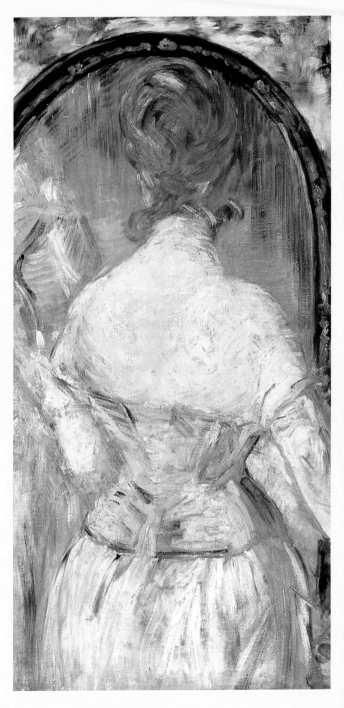

Edouard Manet's **Before the Mirror**, c. 1876.

The Victorian society (1837-1910) was considered a very prudish one. Ironically, in the late 1840s, when repressive prudery was at a high, underwear never ceased to be of interest and was often the subject of censure. Its invisibility is what made it so mysterious, rendering it more erotically appealing than ever before. "Even the word 'petticoat' served poets as a symbol of feminine charm, becoming a synonym for the gender. The drawers, the hoop and the corsets were seemingly forever on people's minds, so much so that the 60 or so years leading up to 1900 were those of the greatest sexual repression as well as the heyday of underwear fetishism."[5]

The ideal Victorian woman had a severe, wasp-like waist. The more tightly laced her corset, the more virtuous she was thought to be. But with virtue came a heavy price: she had a pale complexion, she spent most of her time sitting down, she moved with languid motions and was often breathless. Although sitting down was considered proper etiquette, it was normally a result of fatigue and malnutrition due to the corset's constraints. After all, there was only so much a woman could fit into a stomach that was distorted by pressure and reduced to half its natural size.

Every part of the Victorian woman was covered. The slightest peek of an ankle or glimpse of the upper neck was considered strictly unmentionable. Middle- and upper-class married couples were meant to engage in sexual activity for the sole purpose of procreation. Men were encouraged to satisfy their urges with the increasing population of prostitutes in order to keep their wives pure and untainted. By having dispassionate sexual intercourse with a stranger rather than with their wives, men were in fact regarded as being respectful toward and dutiful to their spouses. The fact that dressing and undressing a Victorian woman was so time- and strength-consuming because of all the layers and laces—women wore an average of eleven pounds of undergarments—contributed to the appeal of scantily dressed prostitutes.

In the early 19th century, men's fashion sometimes imitated women's when corsets were worn to achieve the wasp-waisted look.

Lingerie

Daughters were also strapped into corsets as a way to straighten their backs and thereby increase their dowry. The following correspondence from a young Victorian woman demonstrates the extent of this obsession:

> *Although perfectly straight and well made, I was enclosed in stiff stays with a steel busk in front, while above my frock, bands drew my shoulders back until the shoulder-blades met. Then a steel rod with a semi-circle which went under my chin, was clasped to the steel busk in my stays.*[6]

In reaction to the rigidity of the Victorians, the Edwardians swung the pendulum towards a seemingly more "natural" silhouette, natural only in appearance but in fact completely artificial in structure. The rounded and voluptuous ideal look of the Edwardian woman gave birth to the S-curve, the Kangaroo Bend or the Gibson Girl fashion, a trend that would continue into the early twentieth century. The Edwardian corset was heavily boned down the front to create a straight front line and a figure with a wasp waist, sloping shoulders, a full overhanging monobosom bust, a protruding posterior and distended, rounded hips. Again, daughters were not spared the wasp-waist torture. This anonymous correspondence demonstrates that waist cinching was part of the regimen:

> *I was placed at the age of fifteen at a fashionable school in London, and there it was the custom of the waists of the pupils to be reduced one inch per month until they were what the lady principal considered small enough. When I left school at seventeen, my waist measured only thirteen inches in circumference. Every morning one of the maids used to come to assist us to dress, and a governess superintended, to see that our corsets were drawn as tightly as possible. After the first few minutes every morning, I felt no pain, and the only ill effects apparently were occasional headaches and loss of appetite. I should be glad if you will inform me for girls to have a waist of fashionable size and yet preserve their health. Very few of my fellow pupils appeared to suffer except for the pain caused by the extreme tightness of the stays...*
> *[It] is often a subject of greatest rivalry among the girls to see which can get the smallest waist, and often while the servant was drawing in the waist of my friend to the utmost of her strength, the young lady, though being tightened until she had hardly a breath to speak, would urge the maid to pull the stays yet closer, and tell her not to let the lace slip in the least.*[7]

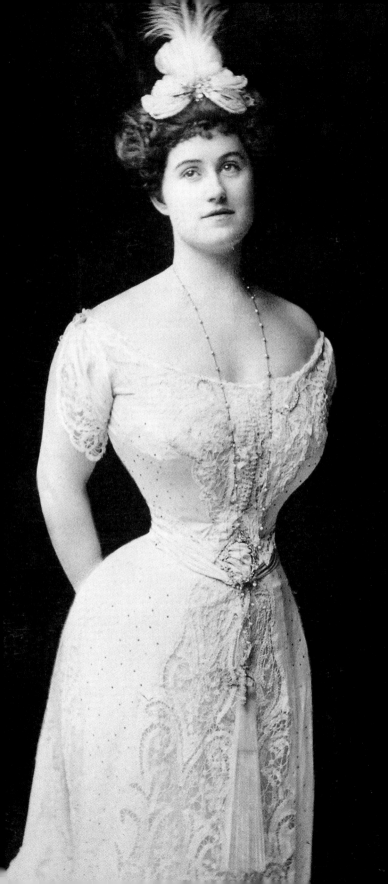

School Days, by Charles Dana Gibson.

This Gibson Girl's dance card is full.

There were aggressive protests against tight lacing from doctors, philosophers and a minority of women from both sides of the Atlantic:

A narrowness of waist betrays a narrowness of minds. When the ribs are contracted, it is a sure sign that the intellect is also. Better to have good lungs and what...is considered a bad figure, than by a tight corset to get a better shape and a worse constitution...She, who, from tight-lacing, cannot draw a long breath, will probably in no time have no breath at all to draw.[8]

But despite the concrete evidence of the distorting and harmful effects tightly laced corsets had on internal organs, the protests had no impact on fashion. Women had a difficult time relinquishing the wasp waist, a symbol of elegance and class. And despite the fact that the women's movement toward emancipation in both England and the United States had made dress reform an issue, it did not have priority over the fight for the right to vote.

The "Gibson Girl" was immortalized in the drawings of the American artist Charles Dana Gibson. She was embodied on the London stage by Camille Clifford.

The industrial revolution of the nineteenth century greatly influenced the development of fashion and corsetry. The world was about to be mechanized and industrialized, from the transcontinental railroad to the steamboat, electricity and plumbing to the telephone and the metal eyelet, these inventions would contribute to the development of the fashion industry. Mechanization of the textile industry facilitated the rapid production of garments at a significantly lower cost. Up until the early 1830s in Europe, corsets were handcrafted and considered a luxury item that only the upper class could afford. In 1861, however, Isaac Singer set up sewing machines in New Haven, Connecticut, for the manufacturing of undergarments, making corsets accessible to practically every woman. The Industrial Revolution was also responsible for facilitating the link between Europe and America, and brought the latest corset styles to the States.

Up until the mid-nineteenth century, natural fibers such as cotton, silk, linen or wool were the basis of all fabrics. But soon, the development of synthetic materials and Charles Goodyear's discovery of vulcanization— a process by which latex fibers are allowed to stretch and then contract—were being used in the manufacture of corsetry. In the 1850s, the first synthetic polymers were developed, soon followed by cellular cotton, which was used to make undergarments that could breathe. But still, women were reluctant to give up the traditional viselike grip of corsetry.

In 1874, two American doctors by the names of Lucien T. Warner and I. de Ver Warner, who later founded the Warner Corset Company, became so concerned over how much their female patients were suffering as a result of tight cinching that they decided to get into the business of corset manufacturing. The "Dr. Warner's Sanitary Corset" was introduced with others, such as the "electric" or "electricity" corset and the first "hygienic" corset made of rubber. But despite an increased awareness of the harmful effects of corsetry, exaggeration again crept in, and

The first Sears, Roebuck catalog (1896) offered more than a dozen varieties of corsets, priced from $1 to $4, some described as being "health promoting."

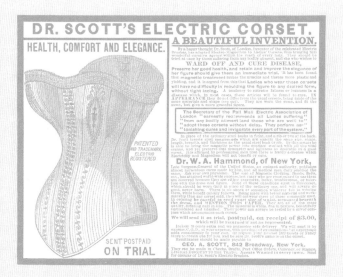

the model waist in 1889 measured thirteen to fourteen inches.

Slowly, though, the concept of a woman as a piece of clay to be molded into a predetermined shape was starting to change. It was replaced by the idea of working with what was already there rather than physically changing it. For the first time, women were paying attention to figure control, the word "control" adding a different spin on women's self-esteem. The slogan "A corset for every figure" generated a tremendous increase in the number of corset manufacturers, as well as wholesale and retail spaces devoted to undergarments. Expenditures on promotional investments skyrocketed. At the Labor Exposition of 1885, artificial breasts—or "bust distenders"—were introduced to the market. These were made from chamois, satin or Indian rubber. Bust distenders were placed in corsets and inflated. Instead of breasts being thrust forward and squeezed together to give the appearance of a swelling bosom, they were increased in size with padding and air. At the Exposition Universelle of 1889, the breast girdle was introduced. This breast girdle, which hung on shoulder suspenders, was the first of its kind

In the 1890s, the English introduced a padded bra called the "Lemon Cup Bust Improver" that contained a coiled spring in each cup which was packed with horsehair.

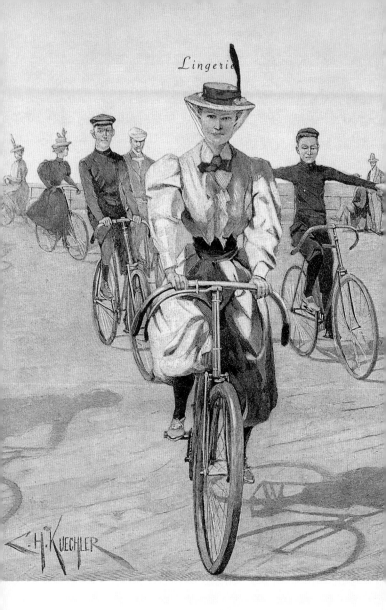

Lingerie

to provide breast support from above (as opposed to them being pushed from below) in a relatively painless garment.

Technological advances in textiles and manufacturing made it possible for women to engage in a new interest—sports. Bicycling was the most popular, providing exercise and transportation, soon to be followed by croquet, international tennis matches, horseback riding and golf. The need for physical mobility would alter the design and manufacturing of undergarments. The famous Ferris corset was introduced specifically to promote a "good sense waist, best for the health, economy and beauty." It was less constricting and had shoulder straps for more support and less

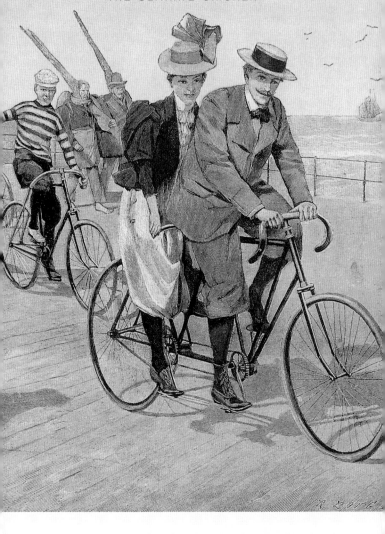

"Bicyclists on the Digue Zu Ostende," by Carl Hermann Kuechler, 1897.

confinement. In 1902, the American Charles de Bevoise created a form-fitting corset cover with built-in shoulders. He called it the brassière, a French word used to describe an infant's under-bodice or harness. The French would call it a *soutien gorge*, which literally means "throat support." Although the dawn of the nineteenth century was beginning to see the woman emerge from her cocoon—at least from an athletic point of view—daytime and high-society corsetry were still resisting change. The waist was constrained in an intricately boned, clasped and laced corset, and the controversy over the garment continued, as is evidenced in this 1905 statement in a trade magazine:

73

Lingerie

Notwithstanding all the talk to the contrary, and a great deal of advertising on the part of the trade converting the American woman to corset shapes as they are understood in Paris and London [which had already softened theirs], the sales of the past few months have proved that the older style of corset is as popular as ever, and the new model is a complete stranger to many women who evince no wish or inclination for an introduction to or acquaintance with it.[9]

For as much as American women were resistant to changing their corsetry, Parisian fashion was on its way to releasing women from the cinching garment. In 1907, the French couturier Paul Poiret was the first to design clothes for a woman's natural shape, instead of women's bodies being shaped to fit the clothes that were designed. Claiming to have single-handedly "freed the bust," Mr. Poiret described his creations as garments which achieved breasts that "rise forth from the bodice like an enchanting testimonial to youth," adding that it is "unthinkable for the breasts to be sealed up in solitary confinement in a castle-like fortress like the corset, as if to punish them."[10] Despite the fact that the Paris Chamber of Commerce, concerned with how this would affect the corset industry and hence the economy, begged Poiret to change his mind, he firmly held his ground.

Accelerating the fall of the tight-laced corset was a combination of events that occurred within the first two decades of the twentieth century. The struggle for women's rights was gaining momentum on both sides of the Atlantic. The tango and ragtime dance crazes made it virtually impossible to dance in a tight-fitting corset. In 1913, Mary Phelps Jacob, an American debutante, invented her version of the garment by tying together two handkerchiefs with a ribbon, leaving the midriff free. She patented the concept and sold it to the Warner Corset Company for $1,500, a patent later valued at $15 million.

But the onset of World War I would ultimately change the course of corsetry forever. For the first time and almost overnight, many women

At the turn of the century, the well-dressed woman spent 1/5 of her clothing allowance on lace-trimmed petticoats.

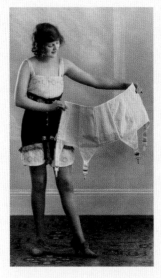

A garment for the new century: the girdle.

were entering the work force in great numbers, taking on such non-domestic responsibilities as nursing, ambulance driving and factory work, receiving paychecks and finding camaraderie and strength in professional unity. The need for more physical flexibility rendered tight-fitting corsets and cumbersome layers of petticoats impractical. Metal-boned corsets were altogether banned from munitions factories. The War Industries Board further issued a call for women to stop buying steel-boned corsets so that the metal could go to more immediate war-time needs. As a result, 28,000 tons of metal were saved in 1917, enough to build two extra battleships. In the face of necessity and demand, the constricting, old-fashioned corset of the belle époque was rapidly losing popularity.

As a result of World War I, women were testing out new identities and experiencing a preliminary taste of independence. With a burgeoning sense of emancipation, and with a need for emotional and physical release tugging at their laces, women were changing their appearances to reflect these internal transformations. Yielding to a natural and more youthful figure, full-length dresses gave way to shorter, loose-waisted ones, and to skirts that rose to mid-calf, which in turn would lead to the creation of shorter under-drawers. The old-fashioned corset and tight-lacing were emphatically rejected, never to be returned to despite many invitations later on to do so.

The antique corset, holding sway for centuries of deforming, cinching, squeezing, molding, constricting and restricting, had finally met its demise.

In 1913, Mary Phelps Jacob decided she was tired of wearing corsets and went to a function wearing two gentlemen's hankies tied together with a baby ribbon.

LINGERIE MUST HAVE

NO. 4

❧

The Comfortable Underwear

❧

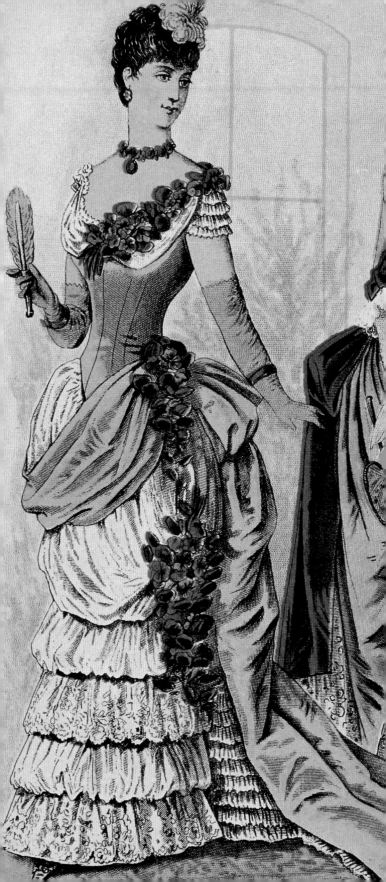

THE
CRINOLINE

Throughout history, the crinoline and the corset thrived in a symbiotic relationship. Although each played very distinct roles, they had one goal in common: to create a specific silhouette for the foundation of garments, the focus of which was a woman's small waist. While the antique tight-laced corset would explicitly show off a woman's figure and enhance middle curves and contours, the crinoline worked in a very different way. The purpose of the crinoline was to create a cone-shaped infrastructure or scaffolding for the lower body which made the fashionable wasp waist look even smaller in contrast with the width of the hem. It would hang from the waist and slope outward and downward, concealing the bottom half of the female anatomy. Speculating as to what might lie underneath—the shape of the upper thigh, the bend of a knee, the turn of an ankle—was enough to drive any man crazy.

Godey's Lady's Book, c. 1880.

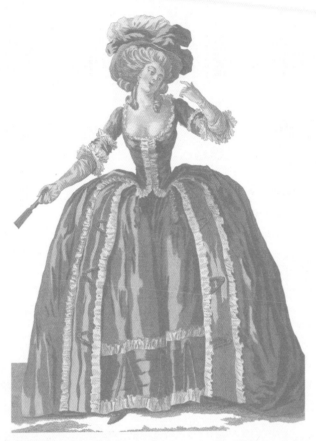

The 15th-century farthingale was so restrictive it disappeared from Europe by the early 1600s.

Crinoline comes from *crin*, the French word for horsehair, and *lin*, the word for linen or thread. Although it specifically described petticoats stiffened with horsehair thread, it was also used to refer to other supporting structures, including hooped and wired skirts. In addition to providing the bones on which to build the hourglass silhouette, the crinoline functioned as a shelf on which several petticoats, and ultimately the outer skirt, could be layered. Since the number of petticoats—the ancestor of the slip—and the quality of the fabrics were a sign of a woman's wealth and social status, crinolines sometimes needed to support a heavy load.

The predecessor of the crinoline was the fifteenth century's Spanish farthingale, also known as the *vardingal*, the *fardyngale* and the *ver-*

thingale. It was the very first artificial support to the lower body. The name farthingale is of Spanish origin, most likely derived from *verdugos*, the Spanish word for "saplings," of which farthingales were constructed before whalebone became the material of choice. The undergarment's graduated hoops artificially extended a woman's skirt to give it a cone-shaped appearance. In addition to being heavy, the underskirt constricted the lower body, trapping the legs and limiting their freedom. The Spanish farthingale quickly made its way to France and England, where it became the French farthingale or *hausse-cul*, literally meaning "posterior lifter" or "bottom support." Padded rolls, or bum rolls, were sometimes attached to the farthingale or directly to the corset, further exaggerating the roundness of the hips and buttocks.

In the late 1500s, when proportions in women's costumes were at their most extravagant, the *hausse-cul* became so large that additional whalebone or cane radiating from the waist was added to petticoats to produce a heavily-boned frame, called the "wheel farthingale." Although women in Spain wore the farthingale until the end of the seventeenth century, it disappeared from the rest of Europe in the early 1600s.

At the end of the seventeenth century and the beginning of the eighteenth, the textile industry in France was producing exquisite fabrics, such as luxurious velvets, silks, and brocades. To sustain the weight of heavier layers and of more elaborate dress, the infrastructure provided by undergarments needed further reinforcement. Hip pads were attached directly to corset stays or to the dress itself. As skirts increased in width and weight, hip pads—now bustles—grew increasingly large. When petticoats and skirts became too cumbersome for even the bustle to support, the French opted for heavy petticoats stiffened with paste or glue, forming a carapace on which the outergarments rested. Eventually, these would be replaced by the hoop or whaleboned petticoats from eighteenth-century England. Whalebone petticoats were bell-

In 1856, some belles wore 16 petticoats under evening dresses. The "inflatable rubber petticoat," advertised as an "air tube dress extender," was meant to serve the same purpose.

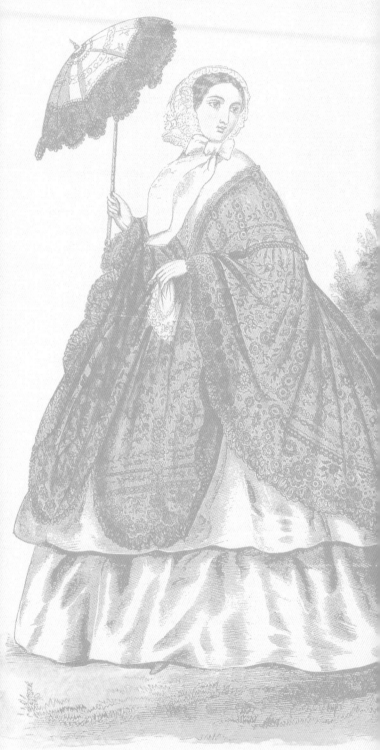

In the 1800s, hoop skirts sometimes extended to a diameter of six feet, and were accompanied by up to twelve petticoats.

shaped at first, creating a full hoop for "full dress" for formal or court attire. A more casual version appeared later on and was distinct from the full hoop in that it had a flattened front and back, making it easier to get through doorways or into coaches.

The full hoop, which the French called *panier* (French for "basket"), was densely whaleboned and very heavy. To alleviate the weight of the contraption, manufacturers experimented with different kinds of stiffeners—from wood to metal—until they discovered the advantages of horsehair. Not only was horsehair lighter in weight while still providing adequate stiffness for support, it was relatively easy and inexpensive to find. Unlike metal, horsehair didn't rust; unlike wood, it didn't break; and unlike whalebone, it didn't need to be imported.

Horsehair-stiffened hoops, which extended to a diameter of up to six feet, appeared in the late 1830s and were called "crinolines." Because these were lighter than their whaleboned ancestors, crinolines of the Victorian era seemed to grow exponentially and became the object of many jokes. To avoid tripping over them, wearers had to take tiny steps when walking. Sitting down was another matter altogether. Hoops were so stiff and awkward that when a woman attempted to sit down with one on, it would generally have no place to go but over her head. In high winds, the crinoline was known to completely flip over, leaving the wearer exposed and vulnerable to drafts since drawers had not yet become fashionable. Walking in narrow corridors or through doorways without getting trapped was equally challenging, as was keeping sweeping skirts away from candles or fire grates. But, to its credit, the crinoline is known to have saved at least one life when it turned into a parachute when a woman who was wearing one jumped off a bridge in an attempt at suicide.

Despite its bad press, though, the crinoline lasted well into the late nineteenth century.

During the first half of the 1800s, fabrics had become heavier and stiffer. The number of petticoats to be worn at one time had increased to

about eleven or twelve. The crinoline on its own could no longer sustain the excess weight and had to be reinforced with additional whalebone or cording, until it too could no longer do the job. In the mid-nineteenth century, the French developed the crinoline cage, an elaborate and expensive structure that only the wealthiest women could afford. It was a bell-shaped skeleton cage made from whalebone or metal. For the first time, women could successfully rid themselves of layers and layers of heavy muslin and petticoats—stiffened or hooped—while retaining the requisite exterior bell-shaped silhouette. Although for the first time legs were indeed freed from encumbering hems, layers and ruffles, the lower body nevertheless remained caged.

With the industrial revolution in England in the late 1860s and early 1870s, the popularity of the crinoline began to wane, in part as a result of the introduction of the railroad, and eventually the advent of the auto-mobile. As travelling became easier and more accessible to a wider class of people, the necessity of wearing "travel friendly" clothing became increasingly apparent. Hoops and wide skirts were by no means practical for getting in and out of train cars, let alone in and out of the house. Legs needed more freedom to move in spaces that could accommodate fewer excesses of costume. As the crinoline started to shrink down, the extra material of the skirt was pulled toward the back of the dress where it was supported by a steel or whaleboned frame-work called the bustle, or *tournure* in French. The bustle, incorporated into the crinoline or petticoat or worn as a separate piece altogether, extended the posterior with a shelf that jutted out from it, creating a rather interesting silhouette profile. Without the inconvenience and awk-wardness of front or side volume, women felt liberated for the first time in many years.

The new bustled silhouette certainly made walking easier—especially with the fashionable high heels of the time—as it did going through doors and stepping onto platforms. One thing that it did not facilitate, howev-er, was sitting down. In 1887, the famed English actress Lillie Langtry, noted for her great beauty and impeccable taste, invented a fabulous little creature: a bustle with springs. This ingenious contraption was designed in such a way that it did not interfere with sitting or leaning; it simply folded up or collapsed onto itself when appropriate.

Like everything else, though, the bustle grew to extremes. Although its

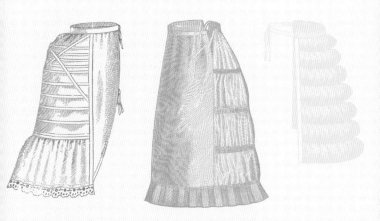

Essential framework for the 19th-century profile.

initial purpose was to add fullness to the back of the dress and to provide a support for gathered material, it eventually became so exaggerated as to create an odd table-like surface that protruded horizontally from the posterior. But even with an oversized backside, women were better off with the bustle than with the crinoline. With the dress falling in natural lines to the front and side, a woman no longer had to worry about tripping over hoops or squeezing into tight places. For the most part, her problems were now behind her, so to speak.

By the end of the nineteenth century, fabrics became lighter in weight and garments less structured. Crêpe de chine, cashmere and chiffon did not need the same support heavier fabrics did, like velvet or silk brocades. Skirts were worn over stiff silk petticoats, and whaleboned supports were rendered almost obsolete. Supple fabrics meant more fluid shapes and styles, which in turn meant a diminished need for undergarments as scaffolding or shape creators. While the road for the chemise dress of the 1920s was being paved, women were literally shedding layers upon layers of underwear, and gracefully stepping out of the hoops of restraint.

> *The advent of the talking picture in the 1920s*
> *killed off the petticoat, as the rustling noise they*
> *made interfered with the sound process.*

At the height of their popularity,
hoop skirts measured up to 10 feet across.

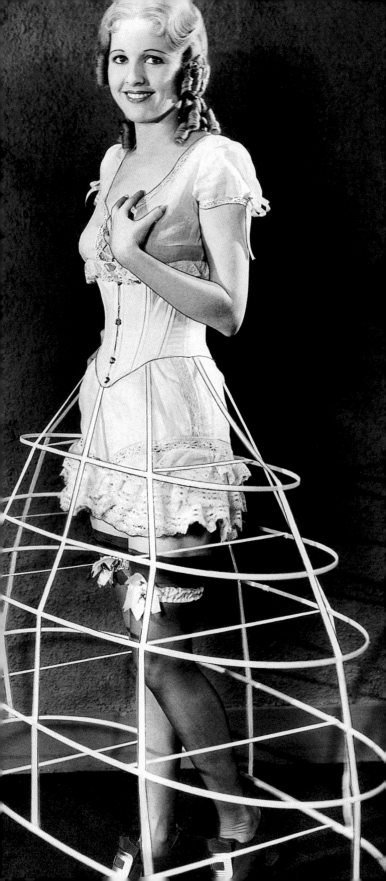

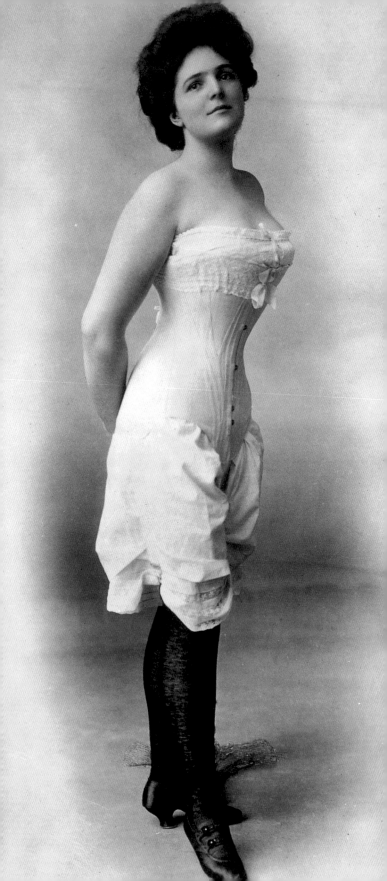

CHEMISES, PANTALOONS & UNDER-DRAWERS

Chemises, pantaloons, knickerbockers and under—drawers were all late bloomers relative to the lingerie scene. Unlike the corset and the crinoline, they did not provide architectural support to the silhouette nor did they help create a foundation for fashion to rest on. They did not cinch, compress, twist or squeeze; they failed to confine, restrict, encage or encase. Since they were not crucial to the aesthetic, they commanded very little attention.

They did, however, provide much needed warmth, with an extra layer or two between the skin and the outergarment, and facilitated hygiene to the extent that they were easier to wash than the clothes themselves and hence changed more often. Neither reason was compelling enough at the time to warrant much attention.

Bloomers add warmth and protection under voluminous skirts and petticoats.

Pantaloons.

Women in general led far less active lifestyles than men, and because their legs were bare under their petticoats well into the 1800s, they needed more underclothing to stay warm. Since the silhouette played such a crucial role in self-definition, and women went through such pain and agony to achieve it, wearing any undergarment on the torso would have increased bulk, thus distorting the well-calculated figure. Instead, women preferred to add an extra outergarment, especially over the upper half of the body, which could be easily removed. Another option was simply to bear the cold, which lead to flus and upper-respiratory difficulties to which the tightly corseted woman was already prone. As far

as the lower half of the body was concerned, it was easier to add an undergarment because no excess bulk would be apparent. Whether or not women could actually fit an undergarment underneath the plethora of petticoats and skirts without feeling completely encumbered was another issue altogether.

From the 16th century through the early 19th century, women were naked under their chemises.

Cleanliness was another reason for wearing underclothes, though protecting the skin from outergarments was not as much an issue of cleanliness as it was of comfort. Before soft velvets, smooth silks and sensual satins, outergarments were made of cruder and more abrasive materials. They were also made to be resistant to weather and to work conditions. Rough linen, jute (a type of rope) and leather were about as comfortable as wearing a potato sack. It made sense to add a little protection between the outer shell and the skin. The principal reason for wearing underclothes, however, was not to protect the skin from the clothing, but to protect the clothing from the skin's oils, dirt and perspiration. This became particularly important around the end of the fifteenth century when expensive fabrics were being used. The correlation between personal hygiene and good health was not well understood until the end of the eighteenth century and the beginning of the nineteenth. Consequently, people bathed rarely and seldom changed their undergarments. The notion of cleanliness that had prompted the Romans to build a complex system of aqueducts and communal baths essentially disappeared during the Dark Ages and wouldn't be restored until many centuries later.

Hygienic conditions in the European courts during the eighteenth century were positively deplorable. With no running water or heat, bathing was a rare event, even among the aristocracy. Washing clothes was no easy feat, either. Many wore the same undergarment—which at the time was the chemise—for long periods, day and night. They would periodically remove the chemises to air them out. Corsets were kept on for days, sometimes weeks, as they were so difficult to put on and remove. Without the means to bathe regularly, people masked their body odor by dousing themselves with perfumes and scented oils and by placing perfumed cones or sachets in their wigs or between their breasts. (This proved a tremendous boon to the development of the perfume industry.) The resurrection of physical cleanliness is attributed to the macaronis.

Macaronis were Englishmen of the late eighteenth century who were often referred to as "dandies" or "fops" because they paid such close attention to their fashion and mannerisms. During the Victorian era, cleanliness became so important that it was seen as a symbol of class distinction. This led to frequent changes of undergarments, which, in turn, led to the development and refinement of the undergarment itself.

CHEMISES

The history of the word "chemise" dates back to the eleventh century. It was used to describe a loose garment the Crusaders wore over their chain mail to protect their metal armors from the sun of the Holy Land. Since then, chemise has come to mean different things and to serve different purposes. In the Middle Ages, the chemise, also referred to as *smock* or *sherte*, was a garment worn either on its own or underneath a robe. In the 1800s, it was synonymous with camisole. In the early twentieth century it was also used to describe the combination, the merger of the corset cover and drawers.

Up until the sixteenth century, the primary purpose of the chemise—an ankle-length garment made of cotton or linen—was protect outergarments from the skin's oils, dirt, and perspiration. The chemise was a very plain garment made of cotton or linen. Since it was never really seen, its design remained the same for a very long time. In the early 1700s, when it was no longer fashionable to sleep in the nude, the chemise was worn at night. Women who could afford it had special chemises made for night wear.

By the middle of the nineteenth century, a woman wore a chemise, a corset, a camisole over her corset, a flannel vest in cold weather, drawers, suspenders for stockings, 6 to 10 petticoats, a hoop skirt and a crinoline.

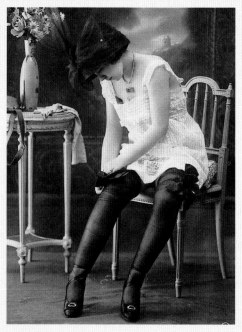

Buckling up a garter in 1910.

As a result of the French Revolution and the Directoire period that followed, fashion in the early 1800s changed drastically, and consequently so did the chemise. During the French Empire, straight, softly flowing, high-waisted dresses made out of sheer fabrics were fashionable. The chemise, made of soft linen or cotton, was worn under the translucent outergarment. It was very simple and exactly followed the line of the dress. Since nightgowns were made in the same style, chemises and nightgowns were interchangeable. As outergarments became more ornate, so—briefly—did chemises. Unadorned chemises came back into style once it was deemed that frilliness was reserved for the world of prostitution. Toward the middle of the nineteenth century, however, chemises again became more ornate and elaborate, trimmed with lace and embroidery. It's only when the style of dress so drastically changed that the chemise was reluctantly given up. It would nevertheless continue to reappear under various shapes and names—it was worn under the corset; it was the precursor to the *teddy*; it was a long shift in the 1920s that was later called a vest. The word *chemise* was also kept by the French, who continue to refer to their nightgowns as *chemises de nuit* (night shirts).

PANTALOONS, BLOOMERS & UNDERDRAWERS

Drawers, the generic term for pantaloons, bloomers and under—drawers, got their name from the way they were put on—they were drawn over one leg, then over the other. These garments were the last undergarment to develop. The reason behind the delay was that it took a very long time for society to acknowledge the fact that women had anything at all underneath their skirts, because whatever was under there was simply unmentionable. Once it was finally acknowledged that women had two legs, every effort was made to conceal them. Eventually, drawers became a symbol of respectability, especially among the Victorians for whom being proper was a way of life.

Although men had worn some kind of underwear or leg covering as early as the thirteenth century, and women had repeatedly tried—unsuc-cessfully—to borrow them from men, women remained naked under their chemises. Apparently, a popular amusement of the eighteenth century was sending young ladies sky-high on swings. A newspaper of 1712 recommended that, before swinging his lady, a lover should "tie her clothes very close together with his hat band before she admits him to throw up her heels."[11] It wasn't until the beginning of the nine-teenth century, when it was no longer considered indecent and unhealthy for women to wear drawers, that these undergar-ments gained acceptability, albeit with great difficulty since anything that resembled two legs was considered masculine.

Some lingerie specialists believe that the fashion of the Directoire period is greatly responsible for the existence of modern-day panties. At the beginning of the 1800s, dresses were straight, light and transparent. At a time that coincides with the awareness and the importance of per-

sonal hygiene, satin drawers in flesh-colored tones became popular. They were two separate legs joined together by a waistband or tape. As the silhouette of the outergarment changed, drawers became longer, wider, shorter or fuller to adjust to the new shape.

In the 1820s pantaloons, inspired by what children had worn at the end of the previous century, were now available to women. Unfortunately, because they were so expensive, very few women could afford them. Three decades later, however, female rights activist Amelia Bloomer, reasoning that long dresses were not suitable for outdoor games and sports, invented a more convenient style of dress. She appeared in public in a Turkish trouser dress that consisted of baggy trousers gathered at the ankle and covered by a skirt which came just below the knee. The trousers, inspired by the Great British Knickers of the 1830s, consisted of two separate legs joined at the waist, leaving the drawers open at the crotch. In defiance of propriety of the times, she wore this type of dress during her public lectures which were attended by huge crowds who came to listen and stare at the spectacle. She urged all women to make a strike for freedom and adopt the trouser style. Elizabeth Smith Miller, a lifelong advocate and financial supporter of the women's rights movement, was one of the first to follow Amelia Bloomer's example. When asked how she came about adopting the new style of dress, she stated: "In the spring of 1851, while spending many hours at work in the garden, I became so thoroughly disgusted with the long skirt, that the dissatisfaction—the growth of years—suddenly ripened into the decision that this shackle should no longer be endured. The resolution was at once put into practice. Turkish trousers to the ankle with a skirt reaching some four inches below the knee, were substituted for the heavy, untidy and exasperating old garment."[12]

But it wasn't until the bicycling craze hit New York in 1880 that Ms. Bloomer's style of dress was universally adopted and became known as "Bloomers."

As fashion called for wider skirts, drawers became wider at the leg.

Josephine, wife of Napoleon, owned 993 chemises.

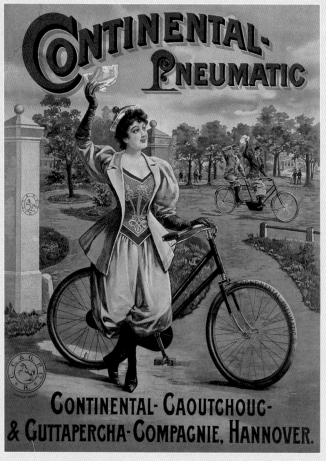

A "bloomer girl" advertises bicycle tires in 1895.

Ironically, despite the fact that they were so delicately embroidered and threaded with ribbon and lace à la Little Bo-Peep, some historians believe that the feminine appearance was just a camouflage for discouraging women from having sex. Coupled with the extensive layers of crinolines, these pantaloons masked the body from the waist down, providing an effective barrier—both physical and psychological—to carnal pleasures. It is also believed that although they were meant to quash the prurient morals of the pre-Victorian era, in fact they had quite the opposite effect. By becoming the focus and frustration of carnal pleasures, "[their] perversity...gave rise to the first recorded strains of underwear fetishism...[as they became] potent totems of sexual control in a

society which was according sex a very bad name."[13]

Because of the multiple layers of trim, embroidery and lace, pantaloons were difficult to wash. Consequently, women wore linings underneath the drawers. Linings were changed almost daily whereas drawers would be changed only every two or three weeks.

As skirts narrowed, wide-legged drawers were replaced by long culottes or skirt panties. Skirts eventually became so narrow women had a difficult time moving their legs above the knee. Because space was limited, the drawers' crotch was sewn together to eliminate the bulky overlapping slit. However, the leg still remained wide. Up until World War I, the idea that any part of the skin would be in contact with the outergarment was unacceptable among the upper class.

By the early 1910s, drawers were brought out into the open by women tennis players or bicycle riders who wore frilly drawers underneath their attire. Different styles were introduced—there were frilly, narrow-legged panties and close-fitting ones that had elastic bands at the waist and knees. As WWI erupted, women working in factories needed as much freedom of movement as possible. Panties were immediately shortened—as was the hemline—and widened.

When the war was over, panties, like fashion, became much more feminine and luxurious. Silk and crêpe de chine panties and all-in-ones (the chemise and panties combination) were popular in bright colors and floral designs. *Camiknickers* with a flap that buttoned between the legs gave women the freedom they needed, while conserving their respectability. As hemlines grew shorter, however, *camiknickers* revealed too much. In order to make them tighter, heavier fabrics that had some stretch like wool or denim were used. These fibers provided the necessary elastic properties but the finished underwear was itchy, hot, bulky and difficult to wash. Nevertheless, women continued wearing them until the late 1920s, when they were finally relieved of some of the discomfort thanks to the invention of man-made fabrics like artificial silk and rayon.

In the 1930s, dresses had become narrow and fashion

dictated that to achieve as smooth a look as possible, undergarments needed to be kept to a minimum and had to be close fitting. Women of all classes had gotten used to the feeling of their skin touching their clothes, and cotton briefs became the underwear of choice. Combinations that covered bras and panties lost their purpose, were considered outdated, and disappeared completely. By the end of the 1930s, underwear basics consisted of a bra, panties and a garter, a far cry from what they had been a century earlier.

Mata Hari—spy, Dutch dancer and femme fatale—
was among the first regular bra-wearers.

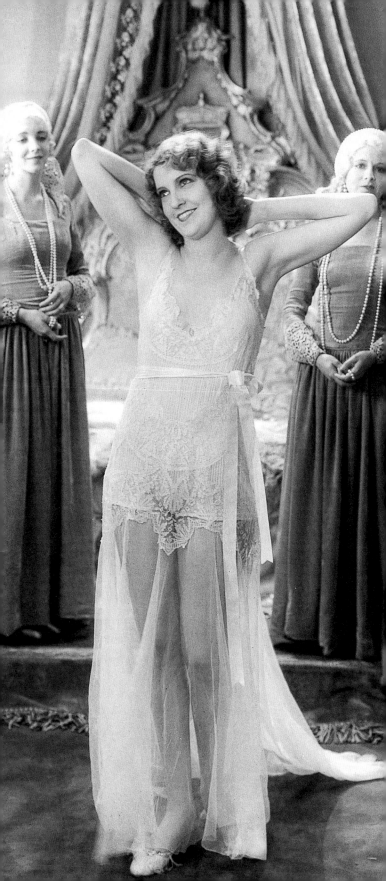

THE TWENTIES

When World War I ended, so did war restrictions. At the dawn of the 1920s, the predominant feeling of relief and exaltation escalated into what the twenties were known for—provocation and excess.

At the close of the previous decade, the Women's Suffrage Amendment had just been ratified. Women cut their hair short, wore short, streamlined dresses exposing the leg, and smoked, drank and ate unaccompanied in public for the first time. The boyish or androgynous look à la Louise Brooks, with bobbed hair and a curveless, slim figure became popular among the young social set—or "bright young things" as they were often referred to—as a way to express the decreasing gap between the sexes. It was called the flapper look.

*Jeanette MacDonald in **The Love Parade**, 1929.*

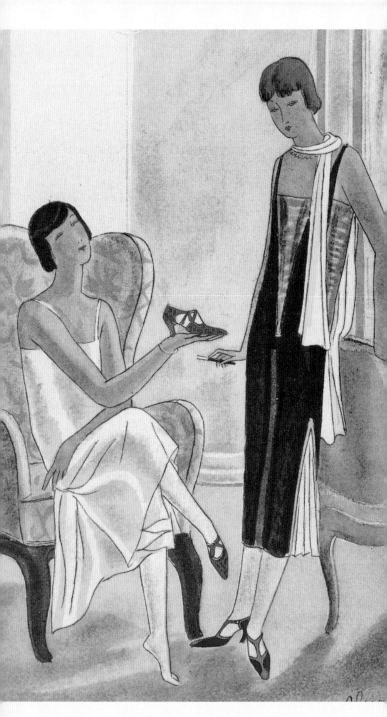

The Dainty Little Slipper, c. 1925, Perugia, Italy.

They wore tight bands of cotton wrapped around their chests and flattening bras to reduce bust size. The non-starch diet, exercise and rubber corsets, which were advertised as a way to lose weight by promoting perspiration and getting rid of excess water weight, were the latest fads.

The shape of the undergarment was changing rapidly. Its focus was now on minimizing curves to create a straight, lean and boyish figure. In order to achieve minimal bulk underneath the twenties–style dresses, some of the layers of undergarments—petticoats, crinolines, chemises and knickers—were eliminated, giving way to combinations. These one-piece garments, such as the *pettiknicker* (combining knickers and the petticoat), and the *camiknicker* (later known as the 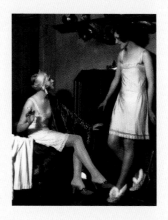 teddy), became very fashionable. The latest item, the *corselet*, was a combination corset incorporating the brassiere. Drawers, until then split down the middle, were sewn up to become knickers, the precursor to the panties of the 1930s. Elaborate garter belts with delicate embroidery were making a comeback, petticoats were emerging as slips and the corset almost virtually disappeared, except for use by heavier women.

As a result of improved diet and exercise, bodies were becoming leaner, and a woman's desire to show herself off and to wear sexier pieces was gaining popularity. On the Hollywood screen, the heartthrob Rudolph Valentino was seducing women left and right, freeing the art of seduction and the suggestion of sex from the closet. After years of repression, sexual morés started to relax, and undergarments became more feminine and coquettish. Fine chiffon, silk jersey, crêpe de chine, linen, artificial silk and silk tricot in pale violets, peaches, roses, ivories,

The boyish flapper fashion of the 1920s inspired Theodore Baer to invent the "teddy" which, unlike its functional cousin the camisole, could be worn on its own.

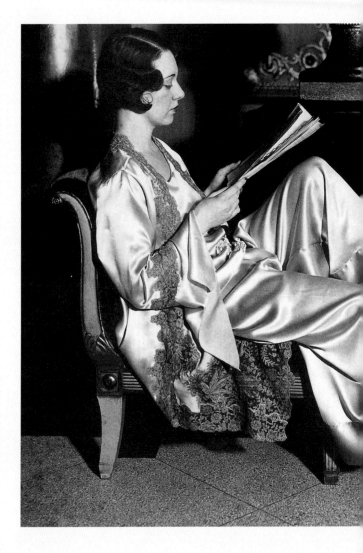

blues and creams, combined with tremendous attention to detail and design, created some of the most luxurious lingerie ever made. It is no wonder that it was during the beginning of this decade, in 1922, that the word lingerie first appeared and officially replaced the word corsetry.

Toward the end of the decade, right after the success of the flapper look reached its peak, the fashion and lingerie pendulums once again started swinging back. With a move away from boyish figures and a return to feminine curves and contours, lingerie designers started focus-

Pajamas and loungewear in glamorous fabrics, rich with detail, are almost too elegant to confine to the bedroom.

ing on shape, particularly on the bust. The Kestos, the first brassiere to define and support the bust—as opposed to just flattening it—was introduced. It proved to be very successful, especially for heavier-set women looking for extra support. The corset, which had disappeared for a few years, was back, but this time as a softer, more supple and slightly boned undergarment that "encouraged" the body into a shape instead of forcing it into another. In 1928, an Australian named Fred Burley who owned a corset factory decided to conduct a study on the size of women's breasts to increase the quality and fit of his product. The results of his investigation would revolutionize the lingerie industry forever. He learned that there were not one but five different kinds of breast types in addition to different sizes, paving the way for custom-made lingerie.

The decade of excess and indulgence soon came to a screeching halt. As a result of the crash of the American Stock Exchange in 1929 and the Great Depression, lingerie sales, which that had soared in the mid-1920s, took a drastic plunge, threatening the existence of many lingerie manufacturers.

LINGERIE MUST HAVE
NO. 3:

The Slip

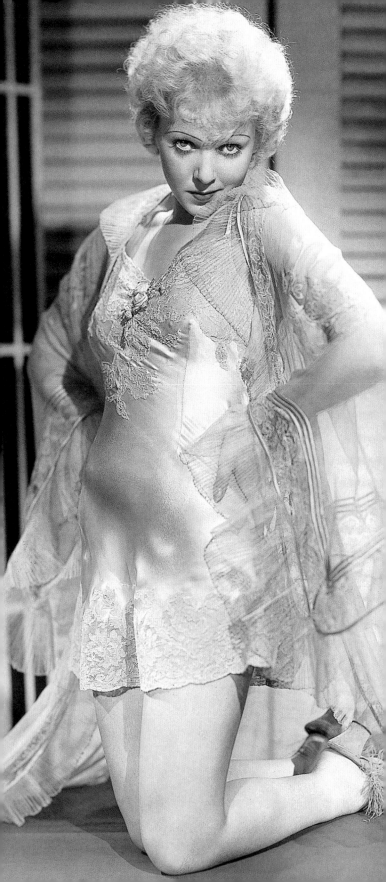

THE THIRTIES

With the Great Depression, the flapper era came to an abrupt close. The carefree attitude of the twenties had quickly disappeared, along with its short dresses and luxurious lingerie. Because people couldn't afford to buy expensive clothing during the Depression years, daytime fashion was much simpler and sparse. Lingerie followed suit, and its design switched its focus to function and convenience, rather than luxury.

*Ida Lupino in **Search for Beauty**, her 1933 American film debut.*

BETTY
BOOP

*Betty Boop made her first screen appearance when
Hollywood decided that no actress might be seen
on screen wearing lingerie.*

In the 1930s, people escaped the Depression by immersing them-
selves in cinema. Actresses like Marlene Dietrich and Greta Garbo
seduced American audiences. Moviegoers were introduced to the likes
of Betty Boop, the sexy, little cartoon character with a short black dress
and garter; Jean Harlow's curves, and Mae West's excessive volup-
tuousness. For the most part, these larger-than-life stars of the silver
screen wore long, silky evening dresses cut on the bias and fit to the bust
and hips, leaving very little to the imagination. It didn't take long for the
worlds of evening fashion and lingerie to duplicate the Hollywood style.
Women who could afford more expensive clothes were so eager to
acquire the Hollywood image for their own wardrobes that department
stores soon carried replicas of movie stars' outfits for sale. The Garbo
look was not only purchasable, but it also came in a variety of sizes!

The thirties was also a decade in which Hollywood not only had a
huge impact on fashion but on the undergarment business as well. In
1922, after the occurrence of a number of scandals involving
Hollywood personalities, the leaders of the motion picture industry
formed the self-regulating Motion Picture Producers and Distributors of

America (M.P.P.D.A.) to counteract the threat of government censorship. Upon his appointment to presidency of the M.P.P.D.A., William H. Hays, a respected national politician and lawyer at the time, initiated a moral blacklist in Hollywood and inserted morals clauses into actors' contracts. In 1934, the American Film Industry passed the Hays Code, a detailed enumeration of what was morally acceptable on the screen, a code which in fact was not totally supplanted until 1966. The effect of the Hays Code was to eliminate all attempts at sexuality, ridding the silver screen of nudity and various stages of undress. In an effort to preserve

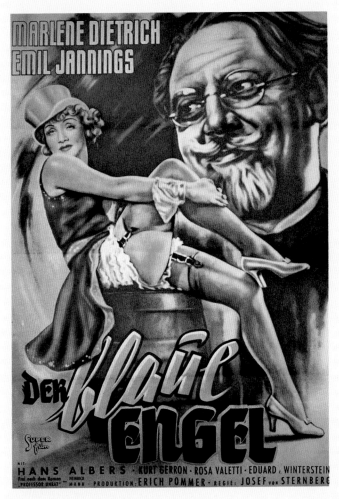

Marlene Dietrich knocked audiences (and Emil Jannings) for a loop garbed in garters in *The Blue Angel*, 1930.

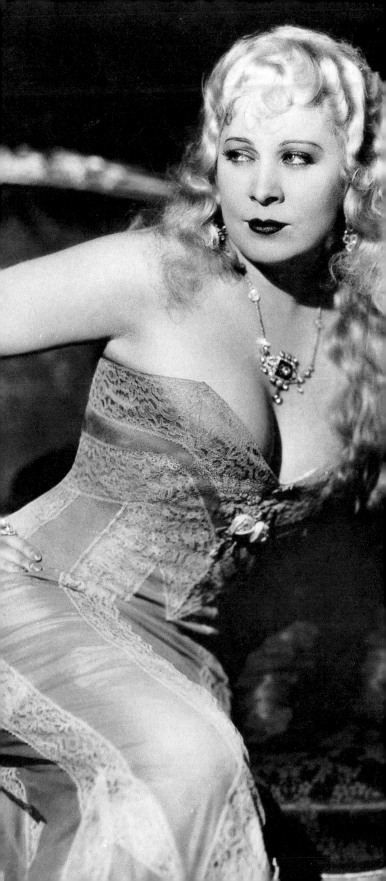

Mae West displays her dangerous curves in **She Done Him Wrong**, 1933.

the sanctity of marriage, it even went so far as to forbid double beds on the screen in favor of twin beds. Consequently, when stars were not portrayed in their silky, fitted dresses, they were shown wearing the finest and most luxurious bedroom lingerie. Long slips or nightgowns replaced all hints of nudity that would have violated the Hays Code and began to symbolize nudity, which drew a lot of attention toward their design. Bedroom lingerie became so sophisticated that it started to look like eveningwear. Full-length slips, evening bed coats, teagowns and nightgowns—referred to as night dresses—in rich charmeuse, satin, crêpe de chine and silk were as form-fitting as evening dresses. On-screen lingerie was a way to express a return to femininity (after the more masculine look of the flapper years) and to distract the audience from the Depression.

In order to maintain the slim lines of Hollywood-style dresses off-screen, lingerie needed once again to play a functional role. To ensure a smooth and bulge-free silhouette under curves and contours, girdles, brassieres and long elastic corsets that covered and compressed the hips were essential foundation garments. Recently developed artificial fibers and technological advances that made it possible to knit elasticized fabric in a circle-like fashion—so that a girdle, for example, was one tube instead of heavily paneled pieces sewn together—were instrumental in

Hollywood censors called sex symbol Mae West's cleavage in her 1934 film I'm No Angel a "living insult to decency."

*The first underwire bra was
introduced in 1938.*

the fabrication of these garments. Rayon, nylon and the modern Lastex, a new two-way stretch fabric, created pieces that were lighter, more durable, wrinkle-proof and easier to care for. Lingerie was very formfitting without hooks or laces and provided various degrees of figure control depending on the fabric's gauge. Knickers, chemises, full-length and short slips, were cut to cling to the body. Girdles and panty girdles were rolled on like second skin and the new zipper made it possible for the more well-endowed, who needed additional support all around, to feel like sexy Hollywood sirens.

In addition to focusing on the functional and practical, lingerie design made a major leap in the thirties in that it started to focus on proper fitting for the individual woman. In 1935, the Warner Company introduced the concept of a bra cup tailored to a woman's breast size with the "ABC bra." The cup-sizing scale was based on an A to D scale, A for the smallest cup and D for the largest, similar to the scale that exists today. The A to D scale was an all-around improvement for the lingerie industry, as it assured women of a better fit and simplified retail orders and inventory. Later, the padded cup for women with smaller breasts would surface, as well as the first underwire bra and backless bra, both originated from Paris.

Toward the very end of the 1930s, fashion took a rapid and almost inexplicable turn. Almost overnight and seemingly without reason, the waist once again became a focal point in fashion. A new wasp-waist type of corset, which laced at the back from right under the bust to hip level, revived fine hand-stitched lingerie to be worn as corset covers.

But as the world was preparing for the onslaught of World War II, the fashion industry, like most industries, came to a standstill. In light of the turmoil and crisis to come, lingerie factories would quickly turn their efforts to the demands of war.

*The form-fitting fashions of the thirties are enhanced by
undergarments customized to the individual figure.*

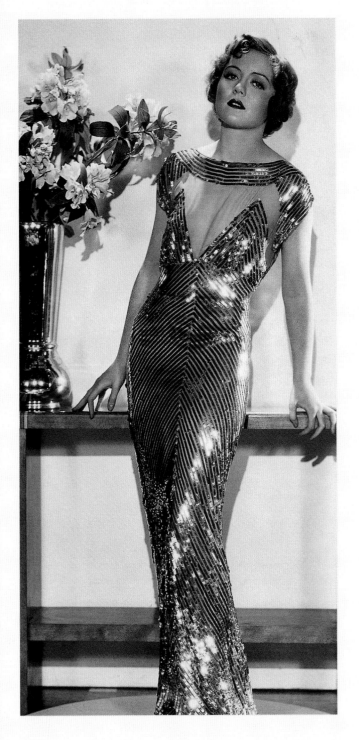

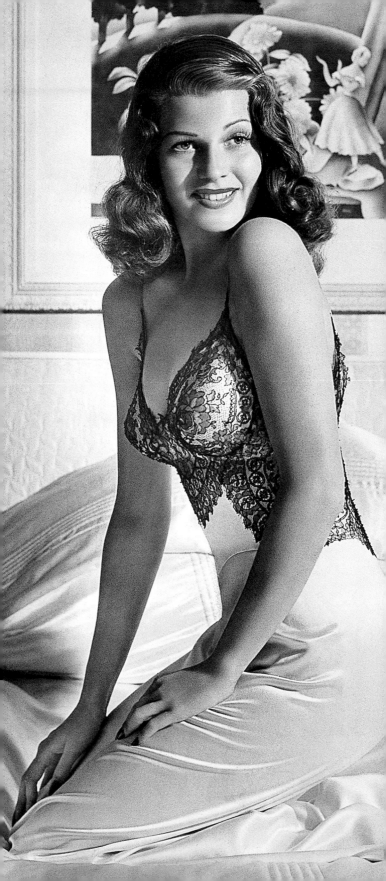

THE FORTIES

The 1940s was a decade of conflicts. Out of the lingerie industry emerged some of the blandest undergarments in history, as well as some of the more luxurious. It was a decade of ingenuity and creativity when the industry made undergarments—or made do—with what was available, and women salvaged whatever pieces of undergarments they could to make new ones. It was also the decade of the sexy Pin-up Girl, whose picture graced the walls of every GI's quarters, and the decade in which the word brassière was abbreviated to "bra."

The classic 1942 pin-up shot of Rita Hayworth was a favorite fantasy object of enlisted men all over the globe.

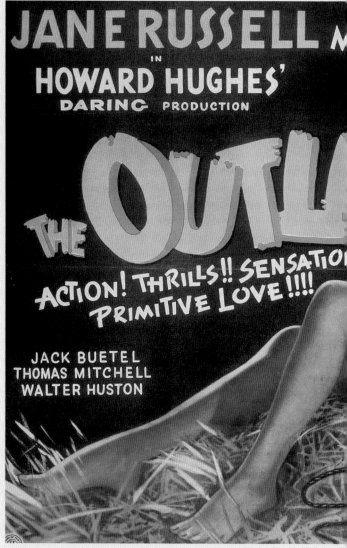

Jane Russell oozes curvaceous sexuality in the 1943 film
The Outlaw, *just before the look gives way to a more sensible style epitomized by Katharine Hepburn.*

With the onset of World War II, Europe was first to suffer wartime rationing and shortages, completely altering the faces of fashion and lingerie. The hourglass figure immediately disappeared in Europe, as it would in the United States in the mid-1940s. On the silver screen, contours and curves of the previous decade gave way to a different look.

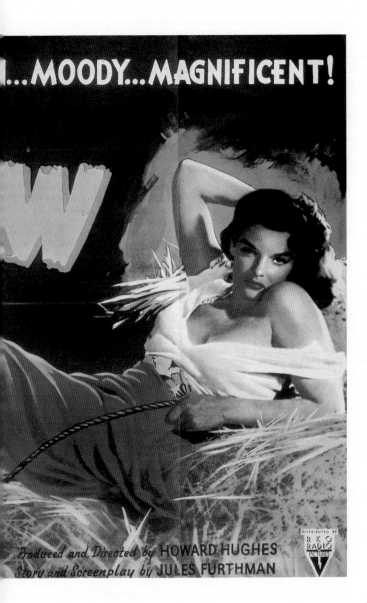

...MOODY...MAGNIFICENT!

Produced and Directed by HOWARD HUGHES
Story and Screenplay by JULES FURTHMAN

In movies like *The Philadelphia Story* and *Woman of the Year*, Katharine Hepburn attempted a more masculine, no-nonsense trend with her signature narrow pants and flat shoes.

Raw materials such as steel, cotton and rubber went to war efforts. Lingerie factories focused their efforts on the war and used these raw materials to meet the needs of the military. Gossard, a bra factory in England, churned out 348 experimental kites, 4,113 convoy balloons,

Fashion form follows function, as women join the wartime workforce.

19,000 life belts, 73,500 sails, 34,807 distress flags, 26,095 man-dropper parachute repairs, 98,700 dinghies, and 639,306 parachutes during the course of World War II. In light of a shortage of resources, the lingerie industry turned to other materials with which to make undergarments, and women turned to their own ingenuity and imagination to satisfy their under-fashion needs.

Although nylon had been invented by E. I. Du Pont in the previous decade (1938), it wasn't introduced to corsetry until 1940, when the first nylon garments were shown at the New York World's Fair. These garments were durable, light, easy to wash, quick-drying and needed little or no ironing. Nylon—whether woven or knitted—had become the fabric of choice.

But even nylon was sometimes in short supply. To avoid giving the appearance of bare legs when stockings were rationed, women often dyed their legs with coffee or special dye and drew a seam on the back of them. Undergarments were repaired at home, with pieces saved from

one garment and used on another, and were recycled from defective or torn parachutes, camouflage nets and life belts. Bits and pieces were even bought on the black market.

As far as design, lingerie was cut to be simple, practical and functional. On the home front, frills and femininity of the previous decade had been abandoned and replaced by all-in-ones such as corselettes, waist cinchers and panty girdles. Tea gowns and loungewear made way for warm and comfortable nightgowns. Since many husbands were overseas, sexy lingerie in the home was placed on the backburner. However, for the men overseas who needed as much moral support as possible, the Pin-up Girl was performing her patriotic duties in slinky and sexy poses.

At the end of World War II, femininity was restored in fashion almost immediately and celebrated with sheer fabrics, colors and lace. American *Vogue* noted that "after the austere years of unpretty lingerie we can have it once again frilled and be-ribboned in the feminine way."[14] The postwar silhouette emerged as a cinched, well-rounded woman with canonized bosoms. From Jane Russell's rather outstanding chest in Howard Hughes's *The Outlaw* to the "sweater-girl look" in the style of Lana Turner, cone-shaped brassieres were the hottest item. The cantilever bra, which was co-created by Hughes, who was also an aeronautical engineer, and the "Rising Star," introduced by Frederick's of Hollywood in 1948 as the first push-up bra, ensured a smooth and voluptuous silhouette.

In 1945, French couturier Marcel Rochas created the guêpière, the newest version of the back-laced corset. A favorite of Mae West's, it was most commonly known as the "waspie" in the United States. This elasticized waist cincher, which would become the foundation garment for Hollywood stars from Jayne Mansfield to Brigitte Bardot to Sophia Loren, was an instant hit.

"Rosie the Riveter" needs simple, functional clothing, inside and out.

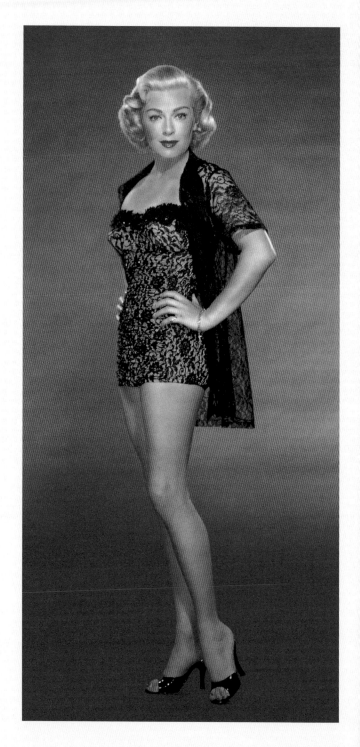

In 1947, French couturier Christian Dior presented his "New Look," emphasizing a small waist, large breasts and rounded hips. Dior resurrected the prewar corset with his own exquisite New Look corselette, frilly crinolines, ruffled petticoats and even removable hoops for added volume. Padded and push-up bras, waist cinchers, combinations of all types—from corset-petticoat combinations to camiknickers and camishorts (step-in panties with a chemise for day or a brassiere for evening)—were essential foundation garments for his line.

Dior's New Look proved to be a tremendous success, despite reservations from a number of American women who felt that the silhouette was a giant step backward with respect to feminine identity. Women had gone to work in droves during World War II. For many, it was the first time they had a job. While their husbands were away at war, many women were also given tremendous responsibility and power. Earning a paycheck and being independent led to a change in their identity. They argued that the return of feminine curves was a way to get women out of the workforce and back into their traditional role of mothering. Others felt that, despite their active and essential role in WWII, they were once again set on a pedestal as beautiful objects to look at. Nevertheless, Dior's buxom silhouette would carry well into the next decade.

The late forties usher in a more buxom silhouette, shown off here by Lana Turner.

Lingerie

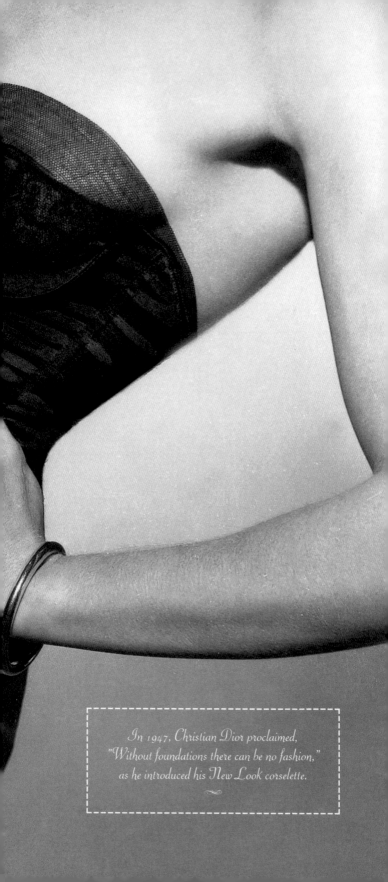

In 1947, Christian Dior proclaimed,
"Without foundations there can be no fashion,"
as he introduced his New Look corselette.

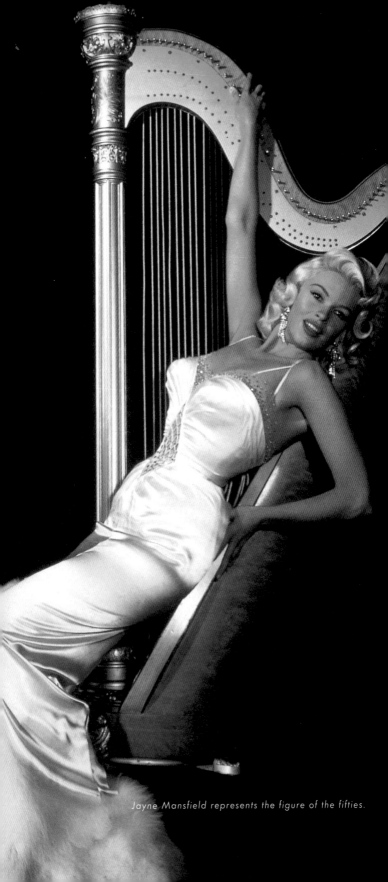

Jayne Mansfield represents the figure of the fifties.

THE FIFTIES

Brigitte Bardot, Gina Lollobrigida, "Baby Doll" Carroll Baker, Marilyn Monroe, Sophia Loren, Jayne Mansfield, Rita Hayworth, Lana Turner, Elizabeth Taylor, Silvana Mangano, Ava Gardner, and Jane Russell. These Hollywood sex icons—to name just a few—epitomized the figure of the 1950s: cone-shaped breasts, a narrow torso and concave waist; sloping hips, a controlled bottom and seemingly long legs. It was the decade that coined bust-waist-hips measurements and defined a woman's silhouette by a set of three double-digit figures, namely 34-24-36. It was also the decade that introduced the Barbie doll to the New York Toy Fair on March 8, 1959, complete with idealized, buxom, slim-hipped figure.

If Barbie were 5' 8", her measurements would be 36-18-22.

Diana Dors sports the "sweater girl" look.

Breast size and shape were crucial to the 1950s silhouette. Designers were kept busy boosting the bustline artificially. They created stylized bras with foam rubber or plastic inserts and wadding (material used for padding), and used spiral or circular stitching to enhance the pointiness of the bra cups, a stitching that Jean-Paul Gaultier used many years later

The first push-up bra was invented in 1956.

to create Madonna's famous World Tour corset. The cantilever bra, which had been created specifically for Jane Russell in *The Outlaw*, was all the rage. The Merry Widow, introduced by Warner in 1952, was soon to follow. Borrowing from the title of the 1952 Hollywood movie starring Lana Turner, the Merry Widow was a strapless corset with attached garters and is considered the precursor to the bustier. Its innovative design essentially cut the bra cup in half, leaving the upper part of the bosom exposed which, with added padding, increased cleavage and accentuated bust size. Warner's advertising campaign for the Merry Widow was enticing: "How can you look so naughty and feel so nice?"

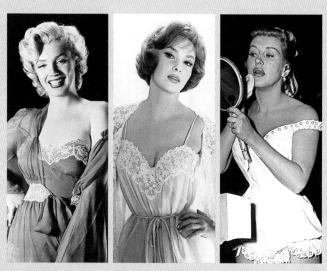

Three icons of fifties glamour: Marilyn Monroe, Gina Lollabrigida, and Betty Grable.

Designers and manufacturers were also experimenting with new types of nylons and nylon blends. Nylon types included nylon net, nylon lace, knit nylon taffeta, voile lace nylon; and nylon blends combined nylon with cotton, wool, silk or satin. The "Little X," introduced in 1954 by Silhouette, was the first corset made out of two-way stretch. Like stock-

The average bust size has increased by 2 inches since the 1950s.

Elizabeth Taylor's body-hugging slip plays a memorable role in **Cat on a Hot Tin Roof**, *1958.*

ings or girdles, it was a roll-on, minimizing the use for hook-and-eye closures and creating a smoother silhouette. The elasticity of the fabric enabled women to adjust the corset to their figure for a more individually tailored look.

The decade of the '50s was also responsible for bringing lingerie out of the bedroom and into the public. Once again, the motion picture industry was instrumental: from Marilyn Monroe's infamous subway-grate scene in *The Seven Year Itch* and her corset-inspired attire in *Gentlemen Prefer Blondes*, to Lana Turner's corset appearance in *The Merry Widow* to slip-clad Elizabeth Taylor's embrace of Paul Newman in *Cat on a Hot Tin Roof*. Sophia Loren was even quoted as saying, "There is no film star today whose underwear we have not seen." Soon, everyone knew what celebrities wore between their skin and sexy dresses...and everyone wanted to do the same. It was also in the fifties that the very first bra advertisement appeared on television. Although the bras were displayed on bust forms, the ads were nevertheless a milestone for the lingerie industry.

Fashion designers, especially European ones, also played an important role in bringing underwear out into the public. To increase customer loyalty and to

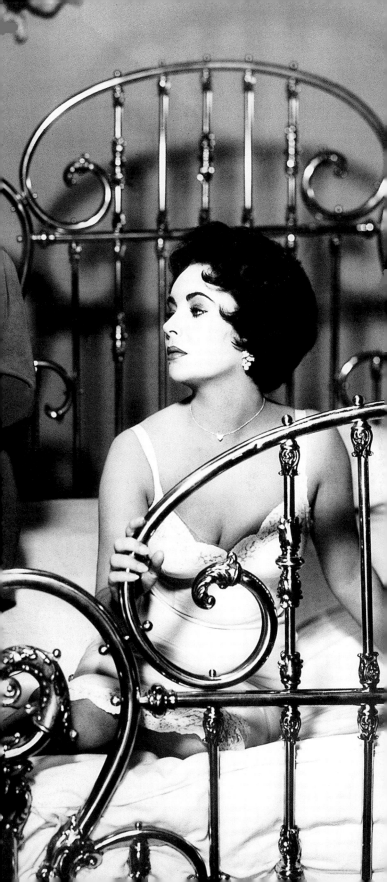

ensure that their couture pieces were worn as they were meant to be, grands couturiers, like Christian Dior, became more and more involved with the lingerie industry. Soon, they were commissioning their own lingerie designers to create undergarments—known as *foundationwear*—that were specifically intended to be worn under the designer's creations and which would be presented during the fashion shows. With the torsolette, Dior was one of the first couturiers to launch his own line of lingerie. The torsolette, a backless and strapless bustier with a plunging neckline, was such a beautiful piece that, when finished with fine beadwork or embroidery, it was worn on its own with a long evening skirt. For the first time since the Middle Ages, the concept of underwear as outerwear resurfaced, as it would again in the 1980s.

In addition to providing the foundations for the elegant woman and her increasingly narrowing skirts, the lingerie industry was faced for the first time with another client to cater to: the teenage girl. The postwar prosperity of the 1950s made its way down to the younger generation. Eager to separate itself from parental conformity, inspired by James Dean's rebellious character in *East of Eden* and *Rebel Without a Cause*, and jolted by the rock-and-roll craze and Elvis's swiveling hips, this new generation was desperate to assert itself. The teenage set found solace in clothing and music. At dances and parties, girls wore the frou-frou petticoat over multiple layers of crinolines and tight sweaters or tops. Since dancing required maximum freedom of movement, panty girdles and bras—not their mothers' corsets—were the undergarments of choice. Lingerie designers and manufacturers were quick to recognize the importance of capturing their future clients' attention at a young age. By 1956, a complete line of lingerie for teenagers and trainer bras for preteens were on the market.

Just before the decade came to a close, Du Pont introduced Fiber K. A synthetic fiber that was stronger and lighter than elastic, it would completely revolutionize the lingerie industry. Fiber K would later be known as Lycra, the future addition to the American wardrobe.

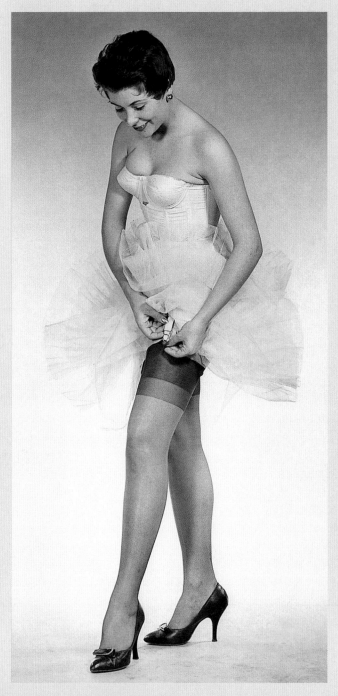

Classic fifties foundationwear, including corset, crinoline, garters, and stockings.

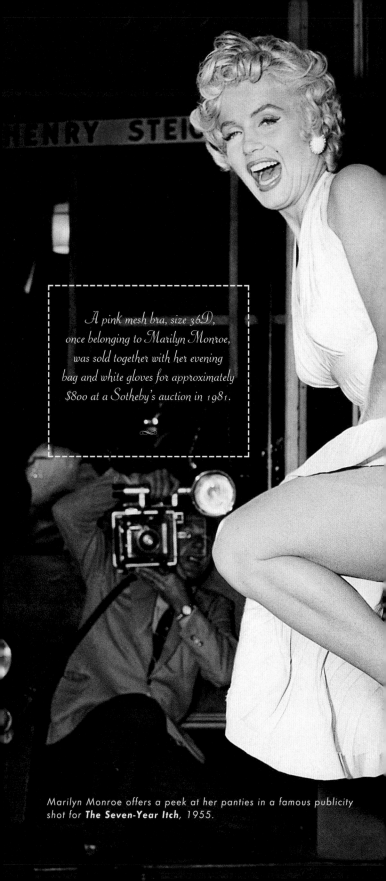

*A pink mesh bra, size 36D,
once belonging to Marilyn Monroe,
was sold together with her evening
bag and white gloves for approximately
$800 at a Sotheby's auction in 1981.*

Marilyn Monroe offers a peek at her panties in a famous publicity
shot for **The Seven-Year Itch**, 1955.

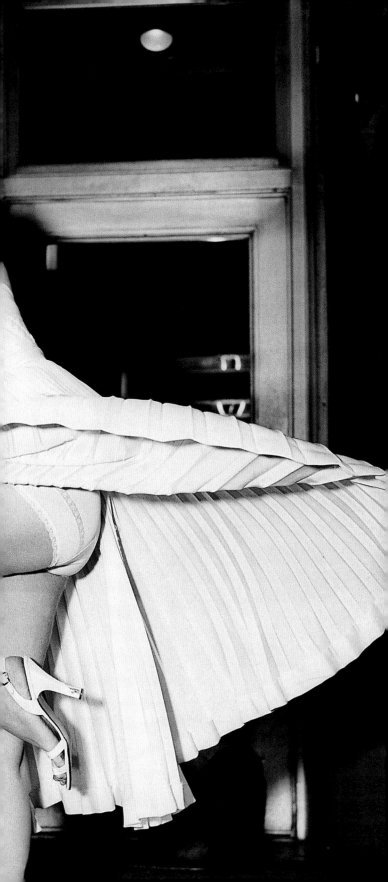

THE
SIXTIES

The 1960s was an explosive decade for young women. The teenage girl of the 1950s had grown into a twenty-year-old whose lifestyle, politics, moral standards and appearance could not be any more different from her mother's. The gap between the two generations was wider than it had ever been. The 1960s young woman was opinionated, outspoken, independent and carefree. She distinguished herself from her parents through her clothes and accessories, music, sexuality and even speech. With the introduction of oral contraceptives in 1963, she was freed from the burden of unwanted pregnancy. For the first time she was in control of her body.

Twiggy's waifish charm launches a new style of dress—and diet.

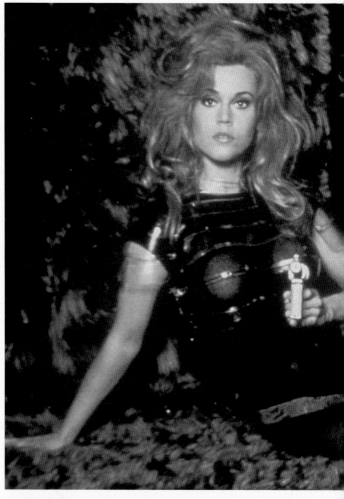

Jane Fonda's 1968 sci-fi heroine, Barbarella, offers a fantasy exception to the no-shape shape of the decade.

The expression "the shape of the ideal woman," as it applies to the 1960s silhouette, is paradoxical. Shape suggests a type of contour that women of the sixties did not aspire to. There was a desired shape—or lack thereof—epitomized by world famous British model Twiggy's tall, thin, almost androgynous or young adolescent boy look, a look that dominated both sides of the Atlantic and that would make a resurgence at the beginning of the 1990s with "waif" models such as Kate Moss and Jodie Kidd. Curves—and everything else from the preceding generation—were completely passé. Fashion and lingerie as Mom wore them

were not only abandoned, but completely rejected. Since the older generation wore long dresses and skirts, the younger one drastically raised hemlines and wore pants more often. Since the older generation wore lingerie to control and shape their bodies, the younger one sought freedom of movement and minimal restraint. While having to cater to an older clientele who was still wearing girdles, garters, elastic corsets, and waist cinchers with padded and shaped bras, the lingerie industry focused on twenty-year-olds, the next generation of consumers, who were not interested in frills or support, but minimalism and comfort.

The women of the 1960s were beginning to feel comfortable with

> *Dolly Parton once said: "When women's lib started,
> I was the first to burn my bra and it took three days
> to put out the fire."*
>
> ᔕ

their shape and sharing it with others. Jeans and miniskirts were cut low on the hip to reveal the midriff. Since skimpy clothes called for skimpier lingerie, panties under miniskirts were smaller than ever, and wearing jeans without underwear was the ultimate freedom. Garters and stockings no longer worked with miniskirts, and girdles were antiquated relics. Bras—still padded and shaped—belonged to an older generation of women who were presumably repressed and who were made to use their appearance to compete for male approval. Burning bras became a symbol for sexual freedom and the women's movement.

If bras were being burned and panties were almost an afterthought, the lingerie industry had to change its approach if it was going to save its own neck. Fortunately for the industry, there was Lycra. Although Lycra, or Fiber K as it was originally called, was introduced in the late fifties, it didn't revolutionize the industry until the sixties. Lycra was unique for it was a light and extremely elastic fiber. The perspiration-proof, machine-washable, quick-drying fiber that required no ironing was ideal for the sixties woman who wanted to spend as little time caring for her lingerie as possible. Short of being disposable, Lycra-based underwear was virtually hassle-free. (Incidentally, disposable panties were manufactured at the end of the decade.) With the right designs, Lycra was ideal for making lingerie that was barely there.

In 1964, the industry launched the "No Bra" bra created by American designer Rudi Gernreich, who had also created the topless swimsuit. It was made of fine, sheer stretch netting. It merely covered the breasts without padding it or shaping it. The "No Bra" bra followed a woman's natural contours, which made it extremely appealing to the liberated woman, and with the introduction of adjustable bra straps it was almost perfect. The industry's revenues were also boosted when it found a way to resolve the miniskirt's garter-and-stockings problem by introducing tights. Panties or panty girdles were incorporated in the design, killing two birds with one stone. Tights were brightly colored and came in all sorts of psychedelic patterns, thanks to new dyeing techniques.

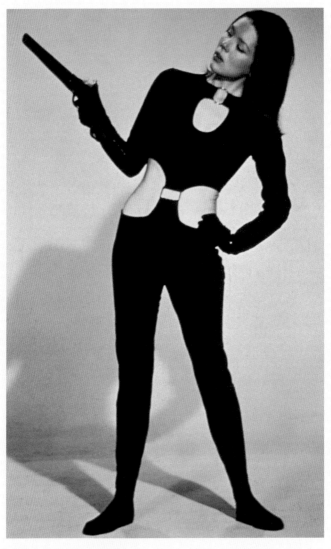

Diana Rigg's unforgettable turn as Mrs. Peel in the popular television series **The Avengers** *makes the catsuit a must-have accessory.*

They were practical and became a mandatory fashion accessory. The catsuit—a tights-bodysuit combo—was instantly immortalized by the famous British actress Diana Rigg in her role as Mrs. Peel in the popular television hit series *The Avengers*. Pretty soon, every woman had to have one in her closet. The garment, originally designed by Courrèges and Rudi Gernreich in the sixties, was reintroduced later in 1990 by Christian Lacroix. In the 1998 movie version of *The Avengers*, the sexy

leather catsuit practically spray-painted on the lovely Uma Thurman as Mrs. Peel, was truly the cat's meow.

In addition to Lycra, mail order had a huge impact on the lingerie industry. Women began buying more of their lingerie from the comfort of their own home through catalogs. Since the first catalogs were geared toward older women, it would take a while for the idea to appeal to the younger generation. But as evidenced by the number of mail-order catalogs today, the concept would prove to be extremely successful.

While the lingerie industry was catering to young women swept

*Dustin Hoffman and Anne Bancroft lunge across the
"generation gap" in the sixties classic,* **The Graduate***—and even
their undergarments emphasize their disjunction.*

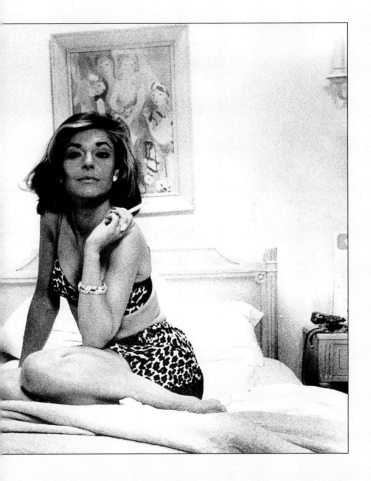

away by the Beatles and the Rolling Stones, and to their mothers as well, it was also trying to cater to yet another class of women. These were the women who belonged to neither generation, neither hippie nor mom, more akin to the slender sleekness and elegant charm of Jacqueline Kennedy and of *Holly Golightly in Breakfast at Tiffany's* than to Twiggy's boyish allure. Their lingerie needs were certainly more conservative than those of their miniskirt-wearing counterparts, but perhaps not as matronly as their mothers'. They wore pieces similar in concept to what the older generation wore, but modernized by design and fabric, and updated with brighter colors and patterns.

With a host of different customers to cater to—from bare-breasted to elegantly curved—the industry was facing the decade to come with an identity crisis.

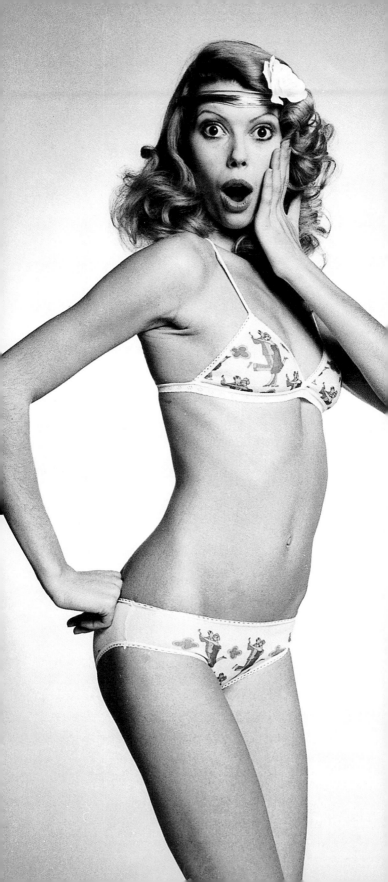

THE SEVENTIES

After a decade of free-spirited indulgence, the generation that went bra-less and behaved so completely recklessly, the generation that brought us *Barbarella's* plexiglass and metallic bra, miniskirts, maxi coats, go-go boots and psychedelic everything, started to pull in its reins. What was once hip—transparent tops, unrestrained sex, drug use, and rampant nudity—had lost some of its appeal, at least in public.

Chesty Morgan, who displayed her 73-inch bust to full effect in the 1975 movie Deadly Weapons, has her bras made to measure.

Lingerie shrinks to the bare necessities to promote a more down-to-earth look.

The seventies' natural and "down-to-earth" fashion lent itself to stocking-sheer nylon bras that were undetectable under tight clothes. They were light, transparent and contoured the body's natural shape, providing comfort with freedom. Some of them, like the music hall and cabaret-inspired G-string, were barely there. They were functional but not overbearing. And the question supposedly on every man's lips was: "Is she or isn't she?"

In her spare time, the woman of the 1970s found ways to channel her physical energy through exercise. In fact, she exercised a lot. Roller skating, disco dancing and jogging were the activities of choice. Undergarments—bras in particular—adjusted to the need for flexibility so that a woman could be ready for any activity at any time. Many sports required special gear and clothing; some even developed their own undergarments. The jog bra, for example, was created in 1977 by two frustrated Vermont marathoners fed up with breast pain after long runs. Consisting of a pair of men's jock straps stitched together (it now hangs in the Smithsonian Institution), the sports bra has become a $300-million-a-year industry.

In 1971, Du Pont introduced Spandex, later known as Elastane, a fiber designed to accommodate movement by stretching easily while also smoothing and shaping the figure. Spandex blends were ideal for making bras and girdles, as they provided shape with a smooth finish. Spandex blends also made great leotards, tights, footless tights and body stockings, or "bodies," for the exercise world. Pretty soon, these same garments were appearing on the runways, blurring the lines between what was worn in the exercise studio, what was worn as outerwear and what was worn as underwear. Bodysuits or stockings worked wonderfully under skirts or under long, fitted gowns to avoid bulges, seams and extra bulk. Leotards or unitards replaced tops and T-shirts, showing off the natural silhouette as much as possible, or were worn as underwear under fitted tops and skirts or pants to provide a smooth silhouette.

The diet and exercise regimen was paying off. Women were proud of their physiques. It made them look good, and more important, it made them feel good. They wanted to pamper themselves and wear nice

Nylon net underwear of the seventies is designed to look natural—even undetectable—under form-fitting clothes.

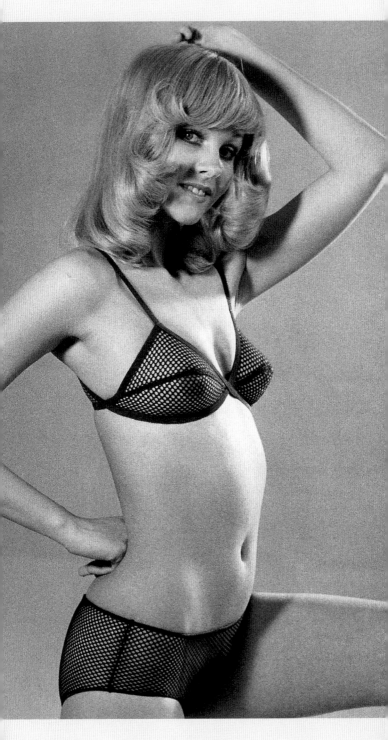

Lingerie

At the start of Woody Allen's film
Everything You Ever Wanted to Know About Sex...,
he is chased by a giant pink bra.

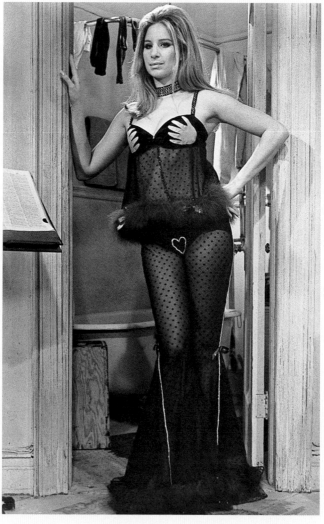

Barbra Streisand's "hands-on" ensemble in **The Owl and the Pussycat**
is a witty (if not subtle) screen alternative to the no-nonsense jog bras
and leotards of the day.

things, not for others but for themselves. They wanted to enjoy their underwear, to feel sensual and seductive. The British designer Janet Reger seized the opportunity and brought underwear back into the realm of the erotic. Reger, known for luxurious silk undergarments that were hand-finished with lace or embroidery, had been designing pieces in Europe since the late fifties. She reached notoriety when her lingerie caught the eyes of a handful of celebrities. Pretty soon, Reger's feminine, indulgent, lacy and sexy camisoles, briefs, teddies, tap pants and panties were the rage. Reger had reinvented elegant lingerie, and other manufacturers quickly followed suit. Victoria's Secret, a company whose name has since become synonymous with lingerie, opened its very first shop.

Meanwhile, a completely different style of lingerie had started to develop. In England the punk movement was growing rapidly. The Sex Pistols, Punk's leading band, had just been signed on by a huge music promoter. Their new image, created by one of Britain's most acclaimed and influential fashion designers, Vivienne Westwood, boasted strong overtones of fetishism and bondage— leather, studs, rings, chains, holes, straps, logos and pornographic images. Punk style spread like wildfire among the younger generation; it seeped into their lingerie drawer and out into the public again. Leather bras and kinky underwear

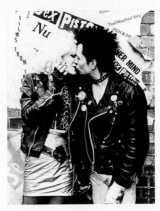

The "punk" fashion of the seventies, modeled here by Chloe Webb and Gary Oldman in the film **Sid and Nancy**, influences a whole generation of fashion— and provides a blanket excuse for a run in the stockings.

were worn as outerwear; garters and fishnet stockings made a comeback. The avant-garde punk street fashions of the 1970s would prove to be hugely influential on the young designers of the eighties.

The 1970s woman embraced a healthy lifestyle by eating well and exercising regularly. The generation gap of the 1960s was quickly closing. Fashion and lingerie were no longer catering to different types of women with different identities, but to the same woman who had multiple interests.

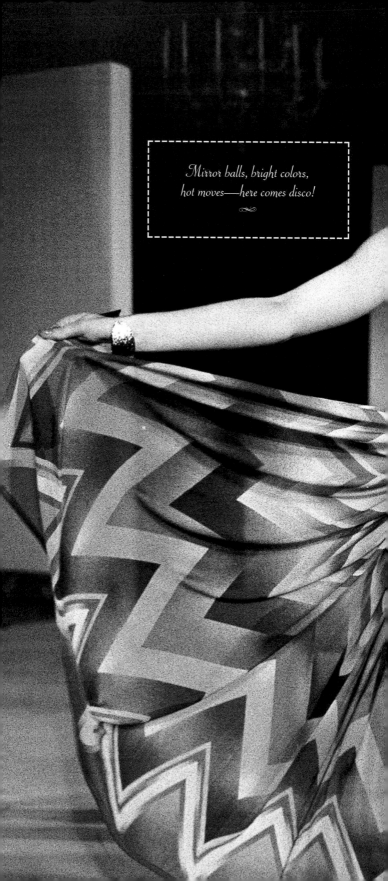

*Mirror balls, bright colors,
hot moves—here comes disco!*

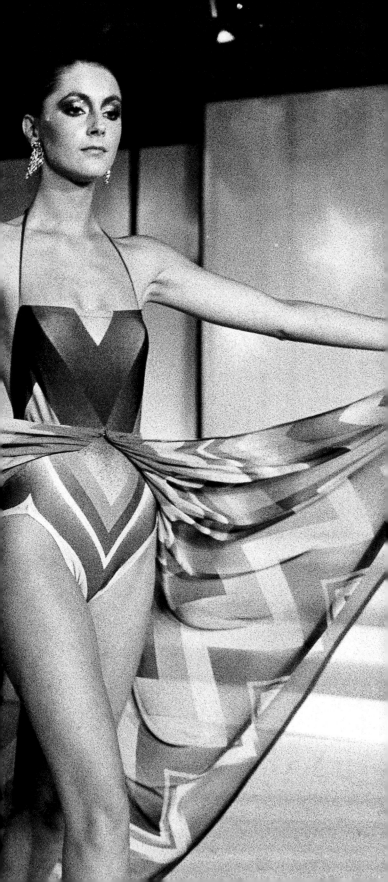

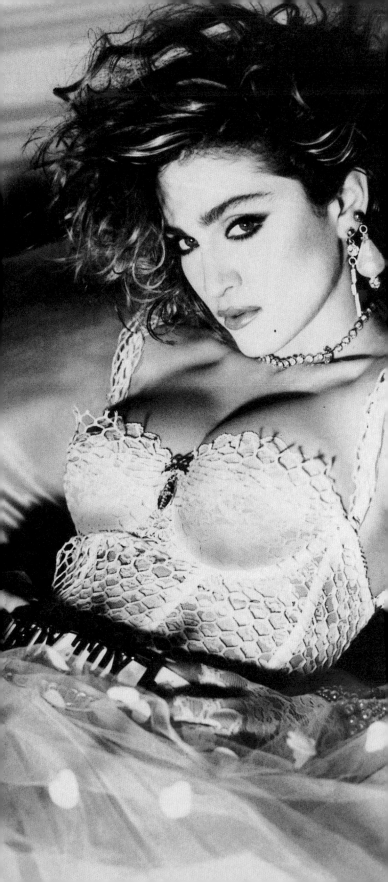

THE
EIGHTIES

The early eighties gave birth to superwoman: she was intelligent, confident, career driven, and attractive. She carried a briefcase and took conference calls, went to power lunches and executive meetings, and was a professional success. She climbed the executive ladder not because of her looks but because of her brains, and made it a point to be understood.

Not since Rita Hayworth's pin-ups and Marilyn's panties has anyone influenced lingerie fashion like pop superstar Madonna.

The eighties woman downplayed her feminine appeal to ensure that she was accepted for what she could achieve and not for what she looked like. At work, she wore men's tailored suits with padded shoulders; at play, she wore clothes made by a new wave of designers from the East. Japanese designers such as Yohji Yamamoto and Rei Kawakubo for Comme des Garcons made clothes that were angular, geometric and almost asexual, concealing shapes and contours. The eighties woman went to the gym religiously in the little spare time she had, took up cross-training, bodybuilding, and was addicted to the StairMaster.

Underneath it all, though, the eighties woman wore luxurious and sexy underwear: lace camisoles, embroidered bra and panty sets, silk teddies and tap pants in romantic colors like pale peach, lilac, rose, ginger and white. Hidden beneath her suits, she wore racy G-strings or tangas with Merry Widows and garters in black, aubergine, turquoise, pomegranate and steel. What she wore next to her skin was for her own pleasure, and perhaps for the empowerment that stems from having a little secret that no one else knows.

By the mid-eighties, the winds started to change. With her confidence boosted and professional success in place, a woman's need to downplay her feminine exterior subsided. The focus instead turned to "refeminizing" the body by showing off its curves once more. But this time the curves would not come from outside forces to shape her physique—padded bras, waist cinchers, or girdles, for example—but from within, through draconian workouts, expensive personal trainers, and fad diets. And whatever Mother Nature had failed to provide naturally was artificially constructed and sculpted. Plastic surgery, silicone injections, stomach, thigh, arm and waist liposuction were becoming common procedures. One prominent surgeon even referred to the eighties as a "breast implant free-for-all." After all, through hard work and perseverance, she had managed to create her own life, so why not mold her own body parts?

Underwear becomes too good to hide in the body-conscious eighties.

The Material Girl struts her stuff in a Jean-Paul Gaultier corset especially designed for her World Tour.

Designers were quick to respond. New lines of Lycra-based and ultra formfitting clothes took over the fashion runways and soon took over the closet. Azzedine Alaia's body skimming skirts, catsuits, bodysuits, minidresses and clinging tops, for example, were ideal for displaying toned legs and gravity-defying chests and left little to the imagination. What was worn underneath—if anything—was a G-string.

Madonna, the trend-setting pop star siren, proclaimed the power of self-assertive sexuality and was responsible for removing the last protective layer and exposing the undergarment completely. In her early eighties "Like a Virgin" music video, she roamed the streets and canals of Venice in her bra and corset-inspired wedding dress.

Onstage, the Material Girl wore lace bras under lace tees or sometimes on their own, and she would make history in the early nineties when she performed dressed in a Jean-Paul Gaultier corset with cone-shaped breasts inspired by the fifties. With the popularity of music videos, it took little time for every teenage girl to follow the trend. It was official—underwear had been ushered in as outerwear. Top clothing designers rushed to create their own lines of underwear. Supermodels, who were once reluctant to do lingerie shoots, became lingerie spokespersons in catalogs, magazines and on television, and scantily-clad Calvin Klein models dominated urban billboards.

Meanwhile, designers like Vivienne Westwood, Jean-Paul Gaultier, Thierry Mugler, John Galliano (Dior), Chantal Thomass and Dolce & Gabbana were working on their next lines. Inspired by the punk street fashion of the seventies, they used unusual materials reminiscent of bondage and fetishism to resurrect corsetry. Basques, corsets, bustiers, garters and crinolines were once again emerging from catwalks and onto the streets.

Calvin Klein's straightforward, "white-bread" approach to under-
wear lets the body itself reign supreme.

THE NINETIES

The 1980s desire to reconstruct and reshape the body through intense physical workout, and a little help from the scalpel, manifested itself in the early nineties in a less aggressive fashion. With body icons like Claudia Schiffer or Naomi Campbell in mind, women were once again turning to lingerie and clothes as the primary tool with which to create or enhance curves, instead of trying to artificially push the limits of anatomy. Fashion designers pulled out their yearbooks and reminisced about the days of structuralism and femininity, when women wore their bullet-shaped breasts high and their girdles tight. Advertisers honed in on the return of bombshell appeal, spurring successful lingerie campaigns with Marilyn Monroe look-alikes like supermodel Eva Herzigova, Adriana Sklenarikkova, and the voluptuous Anna-Nicole Smith.

The "waif" makes a last stand in the form of Kate Moss, seen here in the snakeskin look by Todd Oldham—but breasts are bursting back on the scene with a vengeance (Anna-Nicole Smith, above).

Say hello to the Wonderbra, and the return of the curvaceous woman.

In 1992, a British man invented a water-filled double-D cup bra and suggested using wallpaper paste for an even firmer frontage.

And in 1994, the Wonderbra, which was only available up until then across the Atlantic, hit the United States to save the American woman from the evil forces of gravity. The bra, which was originally designed in 1964 by Louise Poirier, a designer for a Canadian lingerie company, arrived in New York in an armored truck with a motorcade of limousines and models displaying its lift and results, advertising itself as a cheaper and safer alternative to implants. Manufacturers could not produce them fast enough to meet customer demands. In the first week alone, the New York department store Saks Fifth Avenue sold $100,000 worth of the bras.

The women-driven craze for curves, as evidenced by the immediate success of the Wonderbra, generated a host of questions pertaining to female image and gender-imposed sexism. As one Bristish writer suggested: "Wonderbra woman has staged a revolution that throws a completely new light on outdated notions of sexism. The question is this: If so many women want to wear the Wonderbra, how can curvaceous fashion be a sexist anti-woman plot? Why would women actively seek out instruments of their own oppression? The old sex/victim equation has ceased to ring true."[15] She added:

[T]here is a strong possibility that the reborn sex-bomb in fashion is a potent foreshadowing of the coming era of female supremacy. If, as we are being led to believe, the future is female, this is the most powerful vision yet of women who are having it all—and want even more. Retrieving the traditional weaponry of high heels, make-up, hour-glass figures, and adding them to the advantages of education, financial independence and great job prospects created in this generation, is a gesture of untrammelled confidence.[16]

In 1992, a male streaker surprised shoppers in Maidenhead, Berkshire, when he leapt out wearing only a Wonderbra.

Left: *Cindy Crawford in strappy Chanel, 1994.* Right: *The return of the corset, via Christian Lacroix, 1998.*

The success of the Wonderbra was a strong indication that women were ready to shape their physique, defy gravity and do it in an unabashed fashion. On a par with support, the nineties' cleavage had become an accessory in itself. Confident in their sexuality, women wanted to have fun with it and take it out into the open. The underwear-as-outerwear trend that had started in the eighties spurred a return to the fine art of corsetry. Equally responsive to the success of the Wonderbra, fashion designers across the board incorporated it into their lines, each adding their own twist of ingenuity to bustiers, basques, garters and corsets. Karl Lagerfeld was the first to act on it by constructing a corset

with a padded bra to go under his couture suits. In rubberized fabrics, leather with zippers, fine embroidered silks or stretch taffeta with buckles, the corset was resurrected and rehabilitated as the ultimate in evening attire. Blurring the lines between bedroom and ballroom, femininity and fetishism, provocation and abandon, it was worn over tailored men's shirts, voluminous evening skirts and biker shorts.

As the corset took its place with the fashion forward, an interesting trend was developing. Women were once again recognizing the corset for its original purpose and returning to the practices of their great-great-great-grandmothers: waist reduction. The corset was no longer worn just for fashion's sake, but also as a way to take inches off. While at work, at the supermarket or at play, women were faithfully tightening their laces or buckles and "training" their bodies into new shapes. Some reported losing up to four inches without changing their diet or exercise routine. Others enjoyed the snug fit and support; they also liked not having to worry about "sucking it in" at any given moment. The bodybuilding era of the eighties had turned into one of "body training" or torso manipulation, as it was called in Europe.

With body-shaping back in style, the girdle was also making a comeback, perhaps on a less glamorous scale, but certainly on a practical one. Unlike the girdle of the fifties, the Lycra Spandex body shapers of the nineties were light, comfortable, controlling, but more important, they could be tailored to the wearer's needs. Some were made with side panels to reduce thighs, or with stomach panels only so that the posterior wouldn't be flattened, and others came with all-around panels for the full slimming effect. Briefs, panties, slips, tights and swimsuits followed the lead, promising to take inches off a woman's size. Some of these undergarments were made with special fabrics to provide UV protection, massage therapy and cellulite-ridding abilities.

*Famous Wonderbra wearers include
Sharon Stone, Geena Davis,
Kylie Minogue, Heather Locklear,
Pamela Anderson, and Jamie Lee Curtis.*

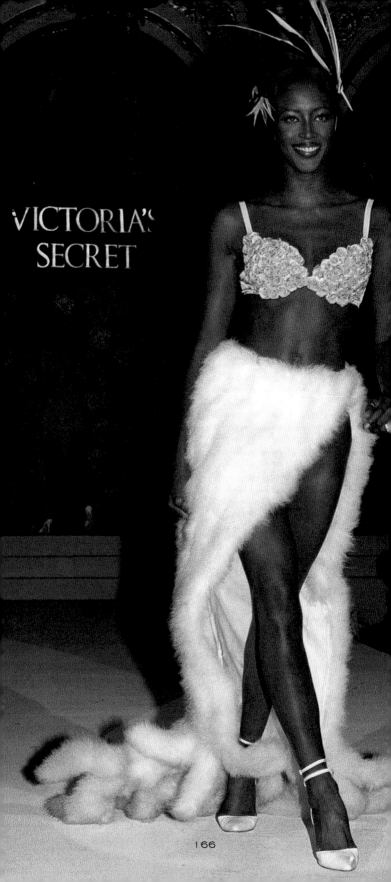

VICTORIA'S
SECRET

166

In 1995, a herd of goats on the Isle of Wight, Britain, were fitted with bras to protect their udders.

Toward the end of the decade, the body became a canvas for ornamentation. Tattoos and body-piercing dominated runways, peeking through diaphanous slip dresses, whispery veils and sheer chiffon shirts, showing up in the most unusual places. Skin and clothing were indiscernible under translucent layers of weightless dresses. Lingerie from the beginning of the decade that emphasized—almost exaggerated—the feminine shape took a back seat to discretion. Women wanted their lingerie to blend into their bodies, barely palpable and almost invisible. Lycra, the body-sculpting fiber that had revolutionized the industry, was making room for a new one: microfiber. Comfortable and soft to the skin, it has been compared to a caress, appealing more to the tactile than to the visual. The result was underwear that was barely there and bras in clean, seamless styles, some of which even had clear straps. Man-made materials—which could now be scented, antibacterial, moisturizing and breathable—were "flesh," "nude," "bronzed" or "tan."

These were the new basics, chameleonesque in nature. They went from the bedroom to the kitchen, from work to play and back again into the bedroom, with ease. Microfiber undergarments became the eighth layer of skin, giving new meaning to "intimate apparel."

Thanks to Victoria's Secret, "unmentionables" have become a mainstream gift of choice.

LINGERIE MUST HAVE
NO. 6:

❧

The Garter

❧

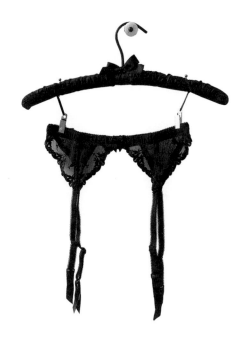

INTO THE
MILLENNIUM

What the next decade holds for lingerie design remains as mysterious as what might lie underneath it. The trend toward simplicity and comfort, and toward the desire to blend body and fabric, which emerged at the end of the nineties, continues to grow and has already planted its seeds in the new millennium. Just as technology is making personalization and customizing a priority—from monitors that read a person's body temperature so that the temperature in a room might adjust itself accordingly, to computers that have been programmed to respond to specific vocal imprints—fashion and lingerie are following the same path.

When it comes to lingerie, who knows what the future holds?

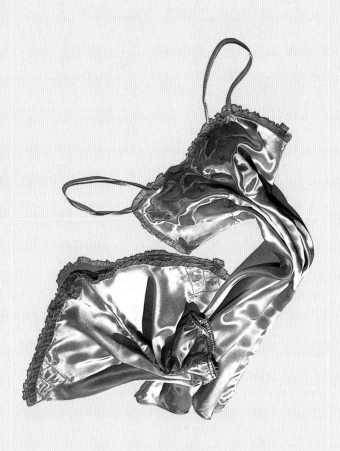

Designers are no longer dictating styles but are focused on giving each woman what she wants when she wants it, by creating designs that adapt to form, texture, environment, individuality and style.

Consider the new lines of custom bras that are hitting the market today: the "X-Bra" launched by Lily of France in February 2000 features a tab pull that shifts the bra to various positions by hoisting and squishing, giving the wearer total control of her cleavage; Warnaco's "Nothing But Curves," a plunging bra designed to boost without padding and which, according to *The Wall Street Journal*, "[lets] women undo one more button on their blouses"[17] and Playtex's "Variable Cleavage Wonderbra," featuring a country-and-western-style bootlace tie at its front and a tiny gilt metal clasp that hoists the bust upwards and inwards with each tweak. There is even speculation that a bra made of hologrammatic fibers, the surface of which creates a 3-dimensional impression to make the breasts appear a better shape, is already in production. Manufacturers have also suggested that a bra of the future could be made from nickel-titanium alloys that would remember the exact shape of the individual woman's breasts, using a technique so sensitive that it has only recently been declassified by the U.S. military. In addition to commanding her own cleavage, the New Millennium woman can pick out pantyhose that will not only shape and support but will moisturize her skin with microscopic aloe beads. She can throw on a pair of panties that will change color with attitude, slide into a tank top with invisible straps that virtually disappear on the skin, and slip into a pre-scented bra or opt for a custom version, the *Sensations* bra, equipped with a special nozzle into which she can pour a few drops of her favorite perfume.

The concept of lingerie as a second skin, quasi-invisible, impalpable, malleable, has created a new kind of garment that is almost a non-garment. Unlike the decade of the Sixties when no underwear literally

Scented underwear was first introduced by the Japanese whose favorite scents include pizza, coffee and cola. The British prefer chocolate and beer

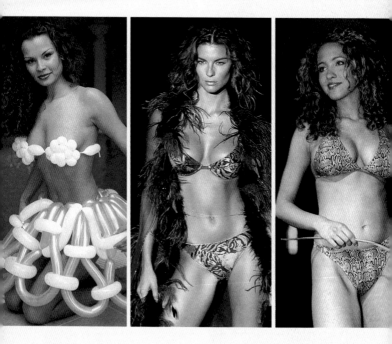

meant no underwear, a symbol of freedom from external control, the non-garment of the Millenium is meant to be incognito, leaving it up to the wearer's discretion whether or not she chooses to reveal any of it at all.

As the boundaries between outerwear and underwear become indiscernible, fashion and lingerie are no longer trying to accommodate each other. Instead, they are subtly merging into one, with each element serving as inspiration to the other. Vivienne Westwood, the doyenne of contemporary lingerie, was once quoted as saying, "Fashion is eventually about being naked." Considering the direction inner-outerwear is taking, the next ten years might in fact become the decade of the unseen.

Japanese designer Junko Koshino's underwear-imprinted evening dress provides a literal interpretation of "underwear as outerwear."

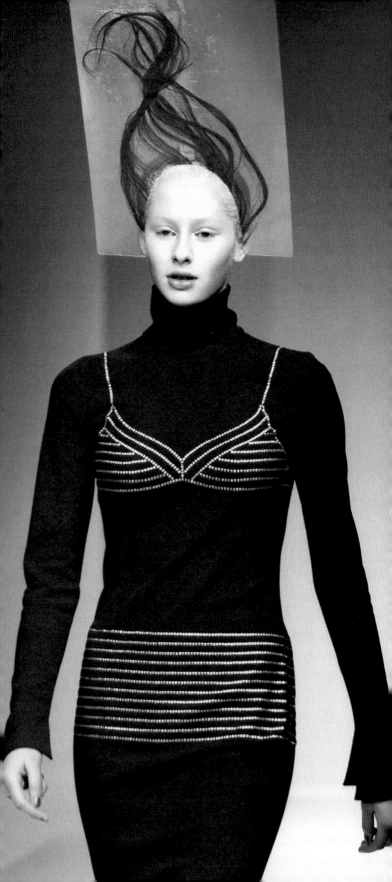

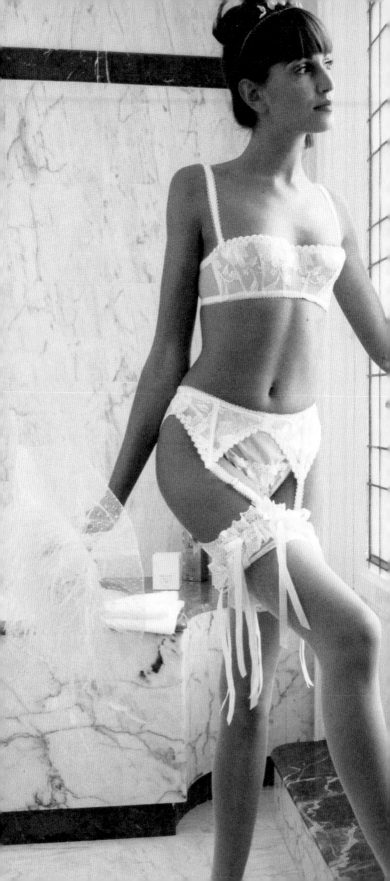

LINGERIE MUST-HAVES

These are the bare essentials of lingerie — those yummy little items that every woman must have in her lingerie wardrobe to make her feel sexy and alluring, to put her in a sensual mood, to induce the hand of another, or to make her feel as if she's carrying a little sensual secret all to herself. Anything short of this list is simply unfathomable.

The Can't-Live-Withouts

The super-sizzling sexy bra
with matching panties, thong or G-string set

Whether dressing for yourself or for your significant other, you can never own too many of these sets. In satin, silk, silk tulle, voile, velvet, or faille, embroidered, laced, floral-toned, ribboned, sheer, patterned, full, push-up, or demi, these delicate pieces are jewel-like, often hand-made, and can get a little pricey. But since you must have one for every occasion and one for every mood, put in birthday and Valentine's Day orders early.

The sexy bra with
matching panties, thong or G-string set

Perhaps not as delicate, fragile, or expensive as the above, but definitely the kind that you wouldn't mind unexpectedly being "caught" wearing.

The teddy

Body-hugging, preferably with a thong back and snaps beneath.
The teddy smooths and flattens the stomach and minimizes lines to a
maximum. It's perfect to wear with tight pants and a fitted top.

The thong

For wearing with close-fitting garments or
when you're feeling a little risqué.

The G-string

For wearing with even closer-fitting garments or when you want to feel
as "close to nature" as possible.

The corset

Even if you end up wearing it only a couple of times a year or on very
special occasions, the fact that you can say that you own one would
send any potential partner into a frenzy.

The garter belt with detachable garters and hosiery

If you're going with a corset, you might as well go for the full effect.
This combination is guaranteed to re-ignite the fire.

The bustier

Some bustiers come with detachable garters, but since it's really an
item designed to be worn as outerwear, save the garters for the corset.

The Ultra-basics

The comfortable bra

A bra for everyday wear, going to work, hanging out with friends, or going to the movies. It doesn't matter if it's wireless or not, front closure or back, with seams or without, nylon Lycra or 100% cotton, it just has to be super comfortable, and machine washable. If you find the perfect one, it's worth buying a half dozen in basic colors (nude, cream, white, and black). Keep in mind that your size may change over time (due to weight gain or loss, pregnancy, change in birth control) and that you might have to splurge every few years for a new fit.

The comfortable underwear

The basic brief, classic or string bikini for everyday wear under lose-fitting skirts, pants, or athletic sportswear. Stock up: different colors, different patterns; no one sees them but you and your alter ego.

The seamless bra

For wearing underneath clingy clothing; completely smooth, completely seamless, body-hugging, and almost invisible.

The sports bra or cropped sports top

Select from one of the many moisture-absorbent fabrics. Certain manufacturers offer a bra selector that helps choose the right bra based on cup size, impact level and activity engaged in. Get two so that one is always handy if the other is being washed.

The multipurpose bra

A bra that adapts to different kinds of tops or dresses—halter, low sides, strapless, criss-cross, regular or low-back.

The microfiber camisole or bodysuit

To wear under sheer tops or to wear as outerwear.
Some camisoles have a built-in shelf-bra for added support.

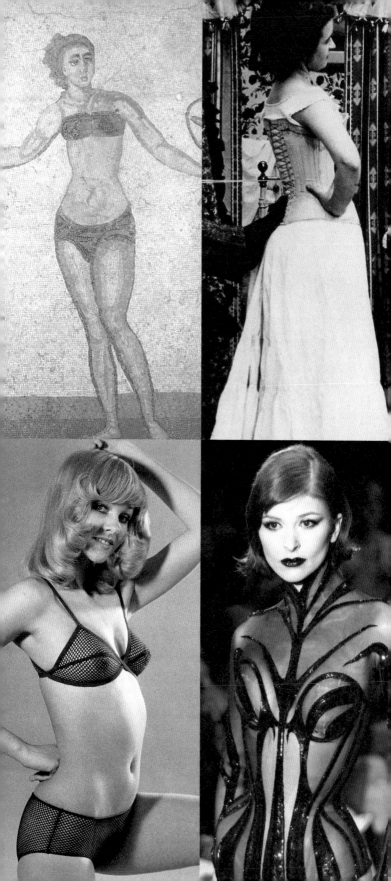

THE CHANGING SHAPE OF WOMAN

The shape of the woman varies over time and from country to country, depending on genetics, nutrition, exercise and health. Whether shaped like a pear or an apple, an hourglass or an athlete, a woman will always be aware of her measurements. Her partner, on the other hand, will most likely ignore them as long as what is measured is scintillating with provocation.

The following measurements reflect the changing shape of women over the years and in different countries.

	BUST	WAIST	HIPS
Present-day American Woman	37 in.	29 in.	39 in.
Present-day Russian Woman	37.6	28.3	39.8
Present-day French Woman	35.7	26.7	36.7
Present-day British Woman	34.7	33.7	36.7
Present-day Swedish Woman	34.7	30.7	33.7
American Woman (1978)	34.5	26	36.5
1925 Survey of American Beauty Queens	34	26	35

Venus De Milo	34	31.2	40.8
Pocahontas	36	18	38
Barbie	36	18	22
Brigitte Bardot	34	23	35
Marilyn Monroe	38	22	36
Jane Russell	39	27	37
Jayne Mansfield	41	18	35
Sophia Loren	38	26	38
Twiggy	32	22	32
Cindy Crawford	34	24	35
Kate Moss	33	23	35
Shalom Harlow	33	23	33
Helena Christensen	35	24	35
Average Playboy Playmate	36	23	35

Statistics based on Adult Data, a survey carried out last year for the Department of Trade and Industry drawing on government and industry polls from around the world.

GLOSSARY

Here is every term you always wanted to know—but were too shy to ask. This complete list will enable you to make specific requests. Circle the items you want, photocopy the list and hand it to your partner. No more lame excuses like "I went blank once I walked into Victoria's Secret and couldn't remember what you asked for."

Baby Doll a short and lightweight nightgown named after Elia Kazan's film "Baby Doll."

Balayeuse a removable ruffle attached to the inside hem of a skirt. It can be taken off and cleaned. The term comes from "balayer," the French word for "to sweep." (1880s)

Bandeau a type of brassiere that hooks at the back and minimizes shaping.

Basque a corset with attached garters (1880s); or section of bodice below waist, shaped to hip (late 20th-century name for corset).

Belt a late 19th-century term for a strap that constricted the stomach, hips and upper thighs, similar to today's concept of a girdle.

Bloomers baggy, Turkish-style drawers launched in 1851 by Amelia Bloomer. The fashion lasted only six months. The term emerged several decades later to describe drawers with closed legs.

Bodies (pair of) a 16th-century term to describe a corset-like covering for the upper body. It was made out of two halves laced together and worn over the chemise.

Body (bodysuit) a one-piece figure-hugging stretch garment that extends from the shoulders to the crotch, usually with snap closures at the crotch.

Bosom Friends padding worn to increase the size of the chest or to add warmth.

Brassière (Bra) a basic bra consists of two cups which cover the breasts and provide support through shoulder straps and an elastic strap across the back; invented around 1912 by a Paris couturière, Madame Cadolle.

Bra Sizes a cup size system (A, B, C, D) developed by Warner that would provide women with more individualized coverage and fit by taking into account that the measurement of the bust and the size of the breasts needed two different scales.

Brasselette a strapless, garterless bustier.

Bretelles French for "suspenders."

Briefs full panties that go up to the waist.

Bum Roll a pillow-like roll worn under skirts and tied to the waist to give the appearance of a protruding posterior. See **Bustle**.

Busk a piece of wood, ivory, steel or horn inserted into the bodice to keep the torso erect.

Bust Bodice a late 19th-century term used to describe a covering for the bust that had straps and was slightly boned in the front and on the sides to give the breasts a mono-bosom effect.

Bustier a bra that extends to the upper waist and often has detachable garters.

Bustier Top a bustier designed to be worn as outerwear.

Bust Improver a mid-19th-century term used to describe padding that was inserted in special pockets in corsets or in dresses to make the breasts look bigger.

Bustle crescent-shaped "pillows" of glazed cotton or silk taffeta padded with straw or cotton wool that were attached to the waist in order to accentuate the posterior or the hips. (1830s). See **Bum Roll**.

Camibra a bra in which the area between the cups is joined by a piece of fabric that makes the bra look like the top of a camisole.

Camiknickers a one-piece undergarment from the early 20th century combining camisole with knickers (the term for women's underpants at the time); later to be known as "the teddy."

Camisette a bustier designed to hug the figure rather than shape it.

Camisole introduced as corset covers in the mid-19th century, the camisole then became an item which provides bust to hip coverage. Combined with knickers, it became "camiknickers" (later to be known as "the teddy") and with the petticoat, it became the slip.

Cavalieri Maillot a topless corset made of elastic material (1930s).

Chemise a plain garment worn under the dress at the beginning of the 19th century. Its purpose was to add a layer of warmth and to keep the outer dress clean from the skin's dirt and oil.

Chemisette in the 19th century, a pared-down underbodice that showed at a low-cut neckline.

Cookies removable pads in padded bras.

Combinations a term to describe a garment which combined two

separate pieces of lingerie such as a chemise and drawers; popular in the early 20th-century.

Combing Jacket a term used to describe a woman's late-19th-century-early-20th-century loose jacket, usually waist-length, worn in the bedroom when brushing hair or applying make-up.

Corselette a corset designed to provide figure-shaping with the use of plastic stiffeners and elastic material; a one-piece garment combining brassiere and girdle (1930s).

Corset a boned or stiffened garment which is meant to support and shape the upper torso; equivalent to the 18th-century "stays" or the 16th-century "pair of bodies."

Corset-Cover the layer between the corset and the dress. See also **Camisole.**

Cotte an old-French term meaning "close-fitting garment."

Crinolette a cage crinoline with hoops only at the back.

Crinoline derives its name from *crin*, the French word for horsehair, and *lin*, the French word for linen. The horsehair was threaded through the petticoat to stiffen it. Later cane, whalebone, and steel were inserted into graduated hoops for s similar effect.

Cuirass derived from the French word for "body armor," this 1870s bodice-like garment was boned, lined and fit closely to the upper body and hips.

Cuties a 1950s term for false breasts.

Demi-bra a bra which does not cover the upper part of the breasts; intended for use with low necklines.

Dickey a bib-like detachable shirtfront.

Directoire Knickers an early 20th-century term for loose-fitting coverings for the upper leg, gathered at the waist and at the knee, and held in place with buttons or elastic.

Drawers originally a term reserved for men's underwear, became popular with women in the eighteenth century for use under their crinoline.

Dress Improver the frame that formed the bustle.

Falsies removable bust pads.

French Knickers short knickers with elastic waist; especially popular in the 1930s and 1940s.

Front-Closure Bra a bra that closes in the front.

G-String a piece of fabric large enough to cover the pubic area and held

together with thin strands or elasticized ribbon.

Garter a band or ribbon worn around the thigh to keep the stocking up before the invention of the garter belt.

Garter Belt an elasticized belt with four elasticized straps (garters) suspended from it; a rubber stub and loop at the end of each garter are fastened to the stockings to keep them up.

Gay Deceivers the first "falsies" or pads ever made whose purpose was to increase breast size when placed inside the bra cup.

Gestation Stays a 19th-century maternity corset meant to be worn during maternity and afterwards to restore the figure.

Girdle a lightweight corset extending from waist to upper thigh, usually elasticized or rubberized.

Gourgandine a laced corset, partly open in front; very popular during the reign of Louis XIV.

Guepière known as the "cincher" in the United States, this new style of corset designed by Marcel Rochas in 1945 had a boned waistband of 5 to 8 inches which hooked at the back and gave even the thinnest women curves.

Habit Shirt similar to a chemisette with a stiffer collar, a habit shirt is meant to peek out from under outer bodices; popular in the early 1800s.

Half Slip a slip that goes from waist to knee, meant to reduce static between pantyhose and a skirt.

Hold-ups Lycra-based stockings that stay up on the thigh on their own.

Hook-and-Eye a type of metal closure now common to most bras, bustiers, and corsets.

Hook Side a side-fastening corset or girdle.

Hoop a bell-shaped understructure to carry petticoats in a wide circumference around the body from waist to feet; usually made out of linen with whalebone or cane.

Hose originally referring to rough-fitting or knitted trousers, hose eventually lead to the creation of pantyhose and stockings.

Jumps an 18th-century term for an underbodice or a looser garment worn for informal undress.

Knickerbockers voluminous drawers (then open at the crotch), gathered at the waist and knee.

Knickers drawers that were fastened under the crotch.

Liberty Bodice a popular camisole-like garment that fastened up the front with

rubber buttons and included extra buttons for petticoats or suspenders.

Lingerie the French word for linen draper and items that came to mean luxury undergarments in the 19th century.

Long-Line Bra a bra that extends to the waist and is often used for figure shaping.

Merry Widow a strapless corset with attached garters introduced by Warners in 1951.

Minimizer a bra that reduces breast size by one cup size.

Morning Dress an informal 19th-century dress taking its name from the time of day it was worn, prior to formal ceremonies and social engagements.

Negligée comes from the French word for "neglected;" a light dress or light-weight gown, usually comes with a matching robe.

Nylons the popular term for nylon stockings from the 1940s to the 1960s.

Panier from the French for "basket," the French term for 18th-century side hoops.

Panty an undergarment designed to cover the lower torso; includes briefs, bikinis, string bikinis, G-strings, tap pants, and thong bikinis.

Panty Corselette a full body corselette with undercrotch fastening; popular in the 1960s.

Panty Girdle an elasticized waist girdle with crotch piece or panty to separate thighs to prevent it from riding up; popular in the 1940s.

Passion Killers women's pants, especially thick and voluminous wartime service knickers elasticized at the waist (c. 1840s).

Pasties decorative nipple coverings.

Petticoat worn in the 15th century as an outergarment and in the 19th-century as an undergarment, it is a term used to describe an ankle-length skirt.

Petticoat Bodice an underbodice or camisole worn with or attached to a petticoat.

Petti-Knickers a term to describe the combination of knickers and a waist petticoat.

Princess Petticoat the combination of a camisole and a waist petticoat designed for wearing under the close-fitting Princess-line dresses named after Alexandra Princess of Wales.

Push-up Bra a bra with a low-cut front, removable pads, and underwire support.

Racer-Back Bra a bra that has a more solid back or straps that form a vee, designed to provide more support for larger breasts.

Ribbon Corset an early-20th-century corset worn for sport or relaxation; it was made of horizontal strips of elastic mounted on a vertical side frame and was meant to encircle the waist and top of the hips for abdominal support.

Robe Volante an 18th-century gown with a fitted bodice and box pleats at the back.

Roll-on the 1930s early prototype of the girdle.

"S" Silhouette or **"S" Silhouette** a silhouette with a full overhanging bust arched into a small waist below with rounded hips (early 1900s).

Shift a loose garment worn next to the skin. See **Smock** and **Chemise**.

Slip an undergarment suspended from the shoulders and extending to the hem of the skirt; usually worn over undergarments and under the outer layer of clothing.

Smock an 11th-century term for what was later to be called chemise.

Soutien-Gorge French word for "bra."

Soft-Cup bra a bra with no underwire.

Sports Bra a bra that is designed to provide support and comfort in sports activities.

Stays a term for a boned underbodice previously known as a "pair of stays" (17th and 18th centuries).

Step-In a type of girdle from the 1930s that was made with elasticized siding, vertical boning and no fastenings so that it could just be "slipped-on."

Stockings see **Hose**.

Strapless Bra a bra designed to be worn with strapless dresses or tops, substituting boning or tight elastic for shoulder straps.

Tea Gown an informal, uncorsetted gown that in the 1920s was appropriate for garden parties and afternoon teas.

Tango Corset a short lightweight corset for dancing in.

Tango Knickers ultra wide-leg knickers for maximum leg movement.

Teddy a one-piece undergarment combining camisole and panties.

Tights a woven one-piece stretch garment covering the feet, legs and waist.

Torsolette see **Corselette**.

Tournure French word for "bustle" for extending the hips or the posterior; popular in the mid to late 19th century.

Underskirt a petticoat worn directly under the outermost layer and usually meant to show through; tends to be more ornate and colorful than underlying petticoats.

Underwire Bra a bra that supports the breasts with metal wires or stiffeners sewn into the lower edges of the cups.

Waist Cincher a type of corset that looks like a belt and is designed to narrow the waist with plastic stiffeners and elastic materials.

Waspie 1940s and 1950s term used to describe belt-like corsets designed to create a small waist.

Wasp Waist a term used to describe a small waist obtained by tight-lacing and corsetry; the term was popular in the 1820s and 1890s, and then again in the 1950s.

Wings material that runs along back and sides of torso for extra support for large breasts.

Wrapper a housedress or housecoat.

FOOTNOTES &
BIBLIOGRAPHY

1. Crawford, M.D.C. *The History of Lingerie in Pictures.* New York: Fairchild, 1952.

2. *Godey's Lady's Book* Online at www.history.rochester.edu/godeys/

3. Genesis 3:7

4. Probert, Christina, ed. *Lingerie in Vogue Since 1910 .* New York: Abbeville, 1981.

5. Govani, Shinan. "Naughty Knickers: What's the Big Deal? It's Only the Layer Between Your Skin and Your Clothes." *The Ottawa Citizen,* October 22, 1999.

6. Stone, Lawrence. *The Family: Sex and Marriage, 1500-1800.* Harper & Row, 1977.

7. Waugh, Norah. *Corsets and Crinolines.* Routledge/Theater Arts Books, reprinted 1998.

8. *Ibid.*

9. Davidson, John. "For the Last Word in Lingerie, the Thong Remains the Same." *The Herald* (Glasgow), September 28, 2000.

10. Kingsley, Hilary. "101 Amazing Things You Never Knew About Bras!" *The People,* April 7, 1996.

11. Magness, Perre. "Underwear Changes an Open Secret." *The Commercial Appeal* (Memphis), December 7, 1995.

12. Appleton, Dorothy. "Amelia Bloomer: Clothes Maketh the Woman." *The Dawn,* July 31, 2000.

13. Bresser, Karen and Karoline Newman and Gillian Proctor. *A Century of Lingerie.* New Jersey: Chartwell Books, 1997.

14. Probert, Christina, *op cit.*

15. Kingsley, Hilary, *op cit.*

16. *Ibid.*

17. O'Connell, Loraine. "Bust Boom." *The Sun Sentinel* (Fort Lauderdale), August 29, 2000.

Appleton, Dorothy. "Amelia Bloomer: Clothes Maketh the Woman." *The Dawn,* July 31, 2000.

Benson, Elaine and John Esten. *Unmentionables: A Brief History of Underwear.* New York: Simon & Schuster, 1996.

Bresser, Karen and Karoline Newman and Gillian Proctor. *A Century of Lingerie.* New Jersey: Chartwell Books, 1997.

Caldwell, Doreen. *And All Was Revealed: Ladies' Underwear 1907-1980.* New York: St. Martin's, 1981.

Carter, Alison. *Underwear: The Fashion History.* New York: Drama Book Publishers, 1992.

Chenoune, Farid. *Les Dessous de la Féminité.* Paris: Editions Assouline, 1998.

Crawford, M.D.C. *The History of Corsets in Pictures.* New York: Fairchild, 1951.

Crawford, M.D.C. *The History of Lingerie in Pictures.* New York: Fairchild, 1952.

Cunnington, Cecil W. and Phillis Cunnington. *The History of Underclothes.* New rev. ed. London & Boston: Faber & Faber, 1981.

Davidson, John. "For the Last Word in Lingerie, the Thong Remains the Same," *The Herald* (Glasgow), September 28, 2000.

Ewing, Elizabeth. *Dress and Undress: A History of Women's Underwear.* New York: Drama Book Specialists, 1978.

Ewing, Elizabeth. *Underwear, A History.* New York: Theatre Arts, 1972.

Godey's Lady's Book Online. www.history.rochester.edu/godeys/

Govani, Shinan. "Naughty Knickers: What's the Big Deal? It's Only the Layer Between Your Skin and Your

Clothes." *The Ottawa Citizen,*
October 22, 1999.

Gray, Mitchel. *The Lingerie Book.* New
York: St. Martin's Press, 1980.

Hawthorne, Rosemary. On Knickers: A
Brief History of "Unmentionables".
London: Bachman & Turner, 1985.

Kingsley, Hilary. "101 Amazing Things
You Never Knew About Bras!"
The People, April 7, 1996.

Kunzle, David. *Fashion and Fetishism.*
Totowa, NJ: Rowman & Littlefield,
1982.

Probert, Christina, ed. *Lingerie in Vogue
Since 1910.* New York: Abbeville,
1981.

Lord, William Barry and R.L. Shep.
*Freaks of Fashion: The Corset and the
Crinoline (1868).* New ed. Mendicino,
CA: R. L. Shep., 1993.

Magness, Perre. "Underwear Changes
an Open Secret." *The Commercial
Appeal* (Memphis), December 7, 1995.

Mower, Sarah. "Winning the War
Against Waifs." *The London Daily Mail,*
December 5, 1994.

O'Connell, Loraine. "Bust Boom." *The
Sun Sentinel* (Fort Lauderdale), August
29, 2000.

Reger, Janet. *Chastity in Focus.* London,
New York: Quartet Books, 1980.

Rothacker, Nanette. *The Undies Book.*
New York: Scribner, 1976.

Saint-Laurent, Cécil. *The Great Book of
Lingerie.* New York: Vendome Press,
1986.

Shep, R.L. *Corsets: A Visual History.*
Mendocino, CA: The Author, 1993.

Stone, Lawrence. *The Family: Sex and
Marriage, 1500-1800.* New York:
Harper & Row, 1977.

Waugh, Norah. *Corsets and Crinolines.*
New York: Theater Arts Books, 1954.

Wilson, Andrew. *Handbook of
Lingerie.* Golden, CO: Hebden Bridge
Publishing, 1996.

PICTURE CREDITS